Crusading Iowa Journalist
VERNE MARSHALL

Crusading Iowa Journalist

VERNE MARSHALL

EXPOSING GRAFT
and THE 1936 PULITZER PRIZE

JERRY HARRINGTON

THE
History
PRESS

Published by The History Press
Charleston, SC
www.historypress.net

Copyright © 2017 by Jerry Harrington
All rights reserved

Front cover, top: Verne Marshall. *Courtesy of the State Historical Society of Iowa.*

First published 2017

Manufactured in the United States

ISBN 978.1.46713.597.9

Library of Congress Control Number: 2016948312

To my wife, Leslie, who is my life's treasure.

I cherish the honor and responsibility that go with an editorship. I ruin no careers that deserve protection, protect no careers that deserve ruin. When I throw the hooks into anyone, they know they've been hooked and the reason. And I've never thrown hooks whose throwing did not serve the public weal.

—Verne Marshall in letter to Earl Hall, editor of the
Mason City Globe Gazette, *December 24, 1930*

I think it is a newspaper man's job to go after any dishonest public official who is pretending to serve the public, regardless of who it is. And when he gets the news he should print it, regardless of how much it costs.

—Verne Marshall, testimony in Sioux City, October 9, 1935

CONTENTS

The Meeting

By 1935, Iowa governor Clyde Herring had grappled with crisis after crisis in his more than two years on the job. Elected as a Democrat in the depths of the Great Depression, Herring assumed office in a rural state suffering from high unemployment and farm prices well below the cost of production. The federal channeling of jobs, money and agricultural programs into Iowa through President Franklin Roosevelt's New Deal had certainly helped, but times remained tough in 1935. Job lines were still long, and farmers still feared foreclosures.

The crisis Herring faced on April 4, 1935, however, in a special meeting in his office at the Iowa State Capitol in Des Moines was unlike any he had confronted before.

Seated before him that day were five other men, four of whom had traveled several hundred miles from Sioux City in Woodbury County on the western border of Iowa. They were Max Duckworth, Woodbury County attorney; William Tice, Woodbury County sheriff; Henry Kuhlmann, public safety commissioner of Sioux City; and W. D. Hayes, Sioux City mayor. The remaining man in the room, like Herring, was a statewide elected official, Edward L. O'Connor of Iowa City, Iowa's attorney general. Also, like Herring, O'Connor was a Democrat elected in the Roosevelt landslide of 1932 that gave Iowa Democrats broad control of state government for the first time in nearly eighty years.

Herring, a middle-aged, bald man and former Des Moines automobile salesman, who looked more like someone's frumpy uncle than the state's

chief executive, got right to the point. "Verne Marshall has absolutely got the goods on you boys," he said, adding, "Marshall has got who collects the money and how it is collected." All in the room knew the issue to which the governor was referring—charges of a statewide protection racket routing money to public officials to allow illegal liquor sales and gambling to go unprosecuted.

The governor glanced over at the Woodbury County sheriff and said, "Tice, your skirts are clean." Looking at Hayes, Governor Herring said, "Mayor, they have got you in it," and he continued around the room. "Mr. Kuhlmann, they have got you in this. Mr. O'Connor, you are in this, and Mr. Duckworth, you are in this."

Herring paused. "What do you boys think ought to be done?" he asked at last.

County attorney Duckworth spoke up: "Well, if this man has the goods on us as he says he has, and has the information and evidence to the effect, the best thing we can do is to go back home and ask that a special session of the grand jury be convened and let him present his evidence there."

The attorney general growled that Verne Marshall wouldn't dare say to his face he "had the goods on him."

Sheriff Tice later said it was noticeable that no one spoke up and denied the charges.

A consensus emerged among these public officials to let the chips fall where they may and prepare to face the consequences. But all, no doubt, were thinking they would fight these charges in the courts and in the broader court of public opinion.[1]

What followed was a whirlwind of legal and political conflict that consumed the lives of everyone in the room—and the citizens of Iowa—for the rest of the year. Soon, both Duckworth and Kuhlmann were forced to resign from office. Hayes vigorously fought for his job against an effort by the city government to remove him. O'Connor was indicted on graft and corruption charges and fought for his political life in a high-profile, seven-week trial that ultimately ended his public career.

Most Iowans were shocked as charge after charge of graft and corruption were thrown at these public officials and many others around the state. One result was the indictment of these men, among nearly fifty others, amid one of the most explosive vice investigations in the history of the Hawkeye State.

The statewide drama resulted principally from the reporting of a single newsman, Verne Marshall, editor of the *Cedar Rapids Gazette*. This crusading

journalist—a reference Marshall absolutely hated—turned Iowa upside down in exposing layer after layer of corruption and protection networks that permeated the state. In story after story in his daily newspaper, this editor raged against statewide graft until officials were forced to act, convening several grand juries in multiple counties and indicting these dozens of individuals.

Armed with his powerful weapons of words, paper and ink, Marshall already had a reputation as a hard-hitting, driven journalist. Time and again in the past, he had shown he was fearless in exposing corruption in public office. Fueled with a vindictive righteousness, Marshall steadfastly believed the role of a journalist was to expose corruption among public officials, no matter the consequences. And this he did throughout 1935. This passion ignited a year like no other in Iowa history, claiming the attention of a nation and gaining for the editor the highest honor in American journalism, the Pulitzer Prize.

But, who was this man who commanded such fear among these politicians? What brought him such a reputation? Who was this reporter?

1

THE REPORTER

Verne Marshall was born to journalism. "He is a newspaperman through and through," wrote the *Des Moines Register*'s Gordon Gammack of Marshall in 1936. "The business is in his blood—blood that sometimes gets hot and shoots words of burning indignation and invective into the columns of the *Gazette*."[2]

It was the *Gazette* that was at the center of the Marshall household. The newspaper was managed by two generations of Marshalls, first by Verne Marshall's father, a family birthright that included the daily publishing of international, national and local news, photos, features, society updates, sports and—most importantly—opinions. In an age before television and the Internet and with radio developing as a news source, the daily newspaper was often *the* source of information for citizens. By the early twentieth century, the *Gazette* had emerged as the principal newspaper of the eastern Iowa city of Cedar Rapids, one of the largest cities in Iowa. And, by the mid-1930s, Verne Marshall was firmly in command of the *Gazette*'s output.

Born in Cedar Rapids on August 30, 1889, Marshall was the son of Harry Lincoln and Emily Kirkland Marshall. It was Marshall's father who first entered the newspaper trade as a young man when he became an apprentice "printer's devil" for his hometown Shellsburg, Iowa newspaper. Harry Marshall got a job at the *Cedar Rapids Gazette* shortly before Verne was born, eventually becoming superintendent of the *Gazette*'s composing room, and in 1914, he bought a third ownership in the newspaper. His business interests also expanded into directorships with the Cedar Rapids Savings Bank and

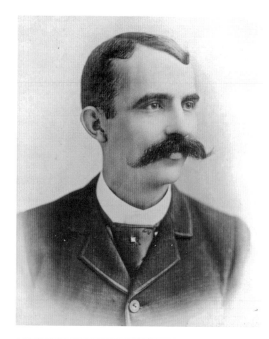

Left: Harry Lincoln Marshall, Verne Marshall's father, began the family's involvement in newspapers, buying a controlling interest in the *Cedar Rapids Gazette* in 1914. *Courtesy of Stevie Ballard.*

Below: A young Verne Marshall poses with his mother, Emily Kirkland Marshall. She urged him to submit an essay on Theodore Roosevelt's inauguration in 1905, prompting him to become a journalist. *Courtesy of Stevie Ballard.*

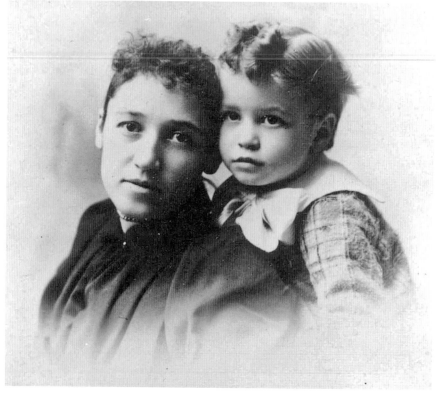

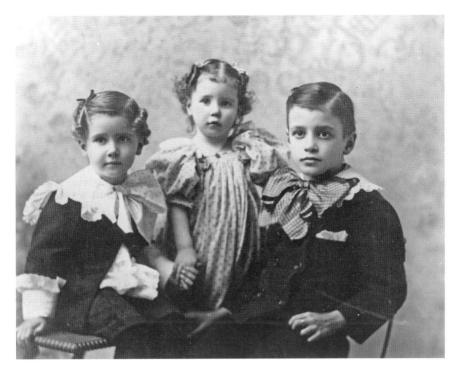

Verne Marshall (*right*) is pictured with his brother Clare (*left*) and sister Margaret (*center*). *Courtesy of Stevie Ballard.*

Trust Company and the LaPlante-Choate Manufacturing Company, makers of house-moving equipment.

The young Marshall's first journalistic experience came when his mother urged him to enter an essay contest by the *Des Moines Capital* newspaper offering a twenty-five-dollar prize to a high school student in 1905 who could write the best essay on the recent presidential inauguration of Theodore Roosevelt. Since Marshall had been to the inauguration in person, he entered and won first prize. The editor of the *Capital* came to Cedar Rapids to personally present Marshall with the prize. Winning the essay inspired the sixteen-year-old to become a newspaperman.

Three years later, after graduating from high school, Marshall took a job writing for the *Cedar Rapids Republican* newspaper, a publication that eventually merged with the *Gazette*, doing day and night work for eight dollars a week. In 1909, he moved to Sioux City, working for the *Tribune* for three years, first as a police reporter and then on the city desk. After that, he responded to the wanderlust common to young men and hopped aboard a cattle boat

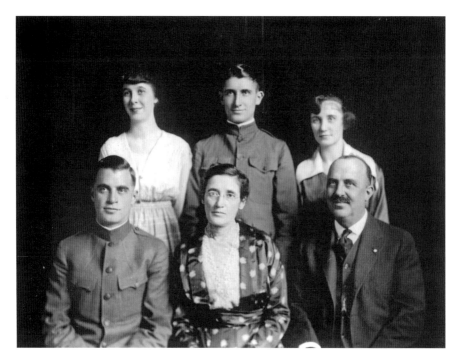

The Marshall family took this family portrait during World War I, with both sons in military attire. Pictured in the front row (*left to right*) are Verne, Emily and Harry and, in the back row are Mildred, Clare and Margaret. *Courtesy of Stevie Ballard.*

for Europe, living a meager life for a year writing for London newspapers at space rates.

Marshall returned to Cedar Rapids after ill health forced him home and attended Coe College there for a year and half. Failing to find interest in college courses, he returned to journalism at the *Minneapolis Tribune* in 1913 and became a reporter for the *Gazette* in Cedar Rapids the next year.

With war raging in Europe, Marshall sought the center of global action and, along with lifelong friend Robert C. Toms of Cedar Rapids, joined the French army in 1916 as an ambulance driver. "I wanted to see the war," recalled Marshall later, "and this was a good opportunity. We arrived in France one day and were at the Verdun front the next. I saw all I wanted in a week."[3]

Marshall returned to Iowa that fall and, when the United States entered the war in early 1917, he relied on his newspaper experience to get a job with the army as war propagandist, traveling the country with Madam Schumann-Heink, a famous singer at the time, promoting patriotic enthusiasm as a war bond speaker.

Returning home after the war, Marshall rejoined the *Gazette* as a reporter in 1919 and settled into married life with Frances Durand Fiske the same year. At that time, the position of managing editor of the newspaper opened with the death of the man who held it, and Marshall jumped at the chance. "I told my father if he didn't give me a crack at the job, I'd quit." Rather than losing a rising journalist, the father hired the son as managing editor of the *Gazette*. The younger Marshall later rose to become the full editor of the newspaper.[4]

It was shortly after beginning this new job that Verne Marshall showed the aggressiveness that would gain him a statewide—and national—reputation as a two-fisted, no-nonsense, fighting reporter who used this newspaper to battle corruption.

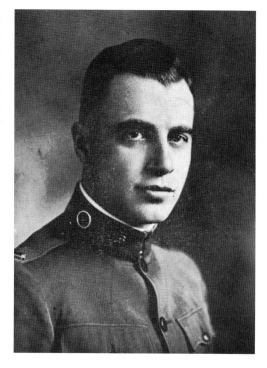

Verne Marshall joined the French army in 1916 as an ambulance driver and helped the war effort in the United States as a war bond speaker. *Courtesy of Stevie Ballard.*

Marshall's first target was the Iowa regulatory system that monitored milk handling to control diseases in dairy cattle. Shortly after the birth of his first daughter, Marshall began searching for guaranteed, whole-certified, tuberculin-tested milk in eastern Iowa. Bovine tuberculosis bacteria in milk, if not managed properly, could infect humans and cause tuberculosis. His search for such certified milk came up empty. As he later recalled, "This was despite the fact that Iowa had had laws on the books for the eradication of bovine tuberculosis, which set forth the processes by which dairy cattle could be accredited and milk for the various grades provided for the public."[5]

The private search became public after Marshall discovered that the man responsible for monitoring cow diseases in Iowa, state dairy and food commissioner W.B. Barney, was a large livestock producer who was actually shipping diseased cattle into Iowa from Wisconsin and selling them to Iowa dairymen. In 1920 and 1921, Marshall wrote a series of exposés in the

Verne Marshall poses while on vacation in Florida in 1929. *Courtesy of Stevie Ballard.*

Gazette, highlighting the information he had uncovered. The result was that Barney was fired and local, state and federal authorities began to enforce the law in Iowa. Cedar Rapids enacted a milk ordinance with teeth in it, and other cities followed course. Iowa soon became one of the few states in the nation where every county was free of tuberculosis in its dairy cattle.

Ten years later, Marshall cast his journalistic eyes to the University of Iowa in Iowa City, thirty miles south of Cedar Rapids. In a controversial series of articles in 1930 and 1931 on the university and the administration of President Walter Jessup, Marshall charged officials with a broad range of financial and ethical violations, as well as conflicts of interest. The primary offense, according to Marshall, was mismanagement of funds from the Rockefeller Foundation that had been granted to the university to construct medical buildings for its hospital. Marshall found that university treasurer W.J. McChesney had invested the funds in the bank where he was also president and paid no interest on the account for years. Marshall also found that university officials were using university houses for private purposes, relying on university employees for private projects and awarding contracts based on favoritism. He also found that Jessup was at the center of an athletic scandal involving payments to students in an era long before athletic scholarships were legal. These exposés were often dramatically splashed on the front pages of the Sunday editions of the *Gazette* with blaring headlines. The university and its allies vigorously protested Marshall's charges, claiming he was blowing them out of proportion.

Prompted by Marshall's articles, the Iowa General Assembly created a special joint investigative committee that met for a month and a half in the spring of 1931 to probe these allegations against the University of Iowa. The group pored through over four hundred documents, interviewed seventy-five people and produced a six-thousand-page transcript of testimony. Recommendations included separating the university treasurer from any banking institution and other reforms. The committee also cited maladministration on the part of university management. As a consequence of the investigation, an audit showed that McChesney had embezzled funds from several university accounts, and a warrant was issued for his arrest in January 1932. After fleeing to Florida, he soon took his life.[6]

Prior to the university investigation, Marshall suffered a personal tragedy with the death of his wife, Frances, in 1928. He married a second time to Clementine Robichaux on May 21, 1932. Eventually, the Marshall household at 532 Knollwood Drive Southeast in Cedar Rapids was overflowing with

Verne Marshall and his first wife, Frances, sit with their three daughters: Jeanne, Barbara and Patricia "Patty." *Courtesy of Stevie Ballard.*

children, five daughters and one son—Jeanne, Barbara, Patricia, Frances, Marie Louise and John Randolph.

By the mid-1930s, Verne Marshall himself, according to one historian, "was a character out of a Sinclair Lewis novel." With his dark hair combed straight back, he wore rimless glasses and was constantly chewing cigars or gum, looking the role of an energetic newspaperman. In an age of

Verne Marshall raised his family, which eventually included six children, in the southeastern section of Cedar Rapids, located at 532 Knollwood Drive Southeast. *Courtesy of the Herbert Hoover Presidential Library.*

restrained language, Marshall was an exception, using "hell" and "damn" in his everyday conversation, especially when referring to his critics—who were numerous. In fact, Marshall often went out of his way to make enemies through his writing.[7]

For instance, during his investigation of the University of Iowa, he had heard rumors that some Iowa City merchants were urging a boycott of Cedar Rapids businesses unless the *Gazette* curbed its criticism of the university. In response, Marshall wrote a two-column editorial the full length of the front page, "A Message to Iowa Citians," lambasting the college-town businesses. Defending his exposés, Marshall wrote, "Those of our advertisers who have been threatened with an Iowa City boycott have not asked and will not ask this newspaper to abandon publication of the truth about the institutions owned by all the people of the state of Iowa, or about anything else that may be worthy of newspaper and public attention....No one in Iowa City or anywhere else, no threats of boycotts, no attempts at blackmailing, no efforts at coercion, can prevent this newspaper from printing these truths."

Verne Marshall's second wife was Clementine Marshall, whom he married in 1932. *Courtesy of Stevie Ballard.*

It was clear that Verne Marshall did not back down from pressure—economic or otherwise.[8]

The name of Verne Marshall was certainly well known to eastern Iowa newspaper readers, as well as followers of political news throughout the state. He had established his signature column on the left side of the *Gazette*'s front page, "Current Comments," carrying his own personal opinions of the issues of the day—international, national, statewide and local—provided in his own unvarnished, blunt style. Distrustful of all authority, Marshall grew critical of Franklin Roosevelt's New Deal through the 1930s and eventually launched full-scale attacks against the administration, placing him firmly on the political right. At the same time, readers of the *Gazette* expected the watchful eye of Verne Marshall to spot corruption and graft among public officials and bring crime to light—no matter who was affected.

One such incident in Cedar Rapids emerged in mid-December 1934, sparking still another torrent of crusading articles from Marshall's typewriter that would expose wave after wave of graft throughout Iowa, reaching across the state and into the highest levels of state government.

It began with a raid.

2
THE RAID

At 11:00 a.m. on Wednesday, December 12, 1934, five city policemen, aided by special Iowa state agents, raided a canning factory at 415 Twelfth Avenue Southeast, in Cedar Rapids. It was not the canning operation, however, that concerned the authorities. The building was a front for another, more covert, business hidden in the basement. The factory, owned by J. LeRoy Farmer, formerly of Wisconsin, doubled as a bar with a slot machine and a punch board, all illegal. During the raid, police seized liquor estimated to be worth $2,000.

The bar was well stocked. Among the bottles and contents seized were fifteen different brands of whiskey, more than twenty pints of California port, several bottles of imported cocktails, Italian wines, cognac, champagne, domestic and imported gins, absinthe and other exotic drinks. The cellar bar was completely fitted with a cocktail shaker, special mixing bottles, white soda, ginger ale, syrups, lemons and limes and other necessary fixtures. No visitor to the establishment could complain of leaving thirsty.

As Earl Stanley, Cedar Rapids chief of detectives, read the search warrant to Farmer in his office while the raid was in process, the owner urged the police not to arrest him or make the raid public, saying cryptically that it would "blow the lid off the state." Neither the Cedar Rapids police nor the state agents took Farmer's advice.[9]

Farmer, in a later statement to the *Gazette*, said the basement room was "just a little amusement place to entertain my friends." He denied selling any liquor. "If someone got in there and sold some of it, I didn't know

it." According to the police, however, someone *had* sold liquor there—in fact, someone had done it earlier that day. Just hours prior to the raid, agents bought five pints of Meadowbrook whiskey in the canning factory basement, paying ten dollars for the liquor. This purchase prompted the raid.[10]

Selling such stock—by the bottle or by the drink—was illegal in Iowa in 1934, except in bottles through the newly created state liquor stores. Earlier in the year, responding to Prohibition's nationwide repeal, the Iowa legislature created the Iowa Liquor Control Commission, which established a state monopoly on bottled liquor sales. The commission was a political compromise between those who wanted to limit liquor use and those who wanted it sold freely on the open market; the Iowa state monopoly sold liquor in state-managed stores. Headed by three commissioners, the state monopoly sold only bottled liquor, which carried state seals, showing it had been purchased at state stores located throughout Iowa. Bringing liquor into Iowa for sale from outside the state was illegal. Only beer—limited to 3.2 percent alcohol—could be sold in glasses over the counter in taverns; selling liquor with higher alcoholic levels by the glass in Iowa was prohibited.

It was selling liquor over the counter and bottles outside the Iowa liquor monopoly that got Farmer in trouble, prompting the raid. But there was a much bigger issue involved: the police discovered that Farmer had in his possession over two hundred Iowa state liquor seals—from the Iowa State Liquor Control Commission, given to him by the head of the commission himself.

At the time of the raid, Farmer pulled out a letter he had received from the chairman of the Iowa Liquor Control Commission, Harold M. Cooper, of Marshalltown. Written on commission stationery and signed by Cooper, it read: "I am enclosing to you some of the state seals for your use in putting on your merchandise which you have in your personal stock. Kind regards. Very truly yours, H.M. Cooper, Chairman, Iowa Liquor Control Commission. Encs. 200 seals." Recognizing the political sensitivity of this revelation, Farmer said to the police, "I would rather take this rap than involve Cooper."[11]

Farmer was right. His arrest would "blow the lid off the state"—first by attracting the immediate attention of Verne Marshall.

This raid on the Cedar Rapids "canning factory" and Marshall's aggressive reporting set in motion a series of events that plunged the highest levels of Iowa government into damage-control mode and consumed the

political oxygen of the state for over a year. The letter and accompanying seals prompted Marshall to sink his primed journalistic teeth into the story, refusing to let go until the answers to his questions were displayed on the front pages of his newspaper.

Upon hearing of the raid, the letter and the seals, Marshall immediately called Commissioner Cooper in his office in Des Moines. Cooper told Marshall he had given Farmer the seals as a "personal courtesy," and Farmer "had a stock of fine old liquors that he had picked up somewhere in Wisconsin, and that he wanted to protect himself by having it all properly labeled." Cooper continued, "I had no idea that he intended to dispose of any of this liquor, and I do not know whether he used any of the seals I sent him on the liquor that he is said to have sold." Marshall wrote a story based on the Cooper information that Farmer had brought the liquor in from Wisconsin and, calling Cooper back, read the quotes to him again, hearing no objections or corrections from the liquor commission's head. In that afternoon's *Gazette*, Marshall reported these comments and emphasized that bringing liquor for sale into Iowa outside the state stores was clearly illegal, citing Commissioner Cooper with conspiring to violate the law he had sworn to protect. Describing Cooper as "inexperienced in politics and the victim of an unfortunate selection of recipients for 'personal courtesies,'" Marshall wrote, "It is not difficult to sense the political and other possibilities in this whole situation."[12]

This situation grew more complicated when Cooper issued a revised public statement later that day, contradicting his earlier account made to Marshall. Cooper said he'd met Farmer the previous summer at a Cedar Rapids Rotary club, describing him as one of the "leading businessmen of the city." The commissioner said that Farmer told him "he possessed a wine cellar in his Cedar Rapids home in which he entertained his friends and that he had a supply of liquors that he had purchased before Prohibition," changing his story about Farmer bringing the liquor to Iowa from Wisconsin. Cooper added that Farmer requested the state seals to place on his liquor bottles because he wanted to obey the law, and the commissioner admitted sending them to Farmer.[13]

This stark contradiction between Cooper's two explanations set off alarm bells with Marshall, ones that would not stop ringing for over a year. For the *Gazette* editor, there was more to this story than a simple liquor raid.

Democratic governor Clyde Herring, who had appointed Cooper to the post, called the incident "regrettable" and said he would talk to Cooper about it, adding that it was a "closed incident."

Marshall disagreed. Writing in the *Gazette*, Marshall said, "Governor Herring says it is 'regrettable' that Chairman Cooper of the Iowa liquor control commission gave away commission seals for illegal use on illegal liquor in Cedar Rapids, but that it is a 'closed incident.' The governor, unfortunately, is one part right and about nine parts wrong. The incident was regrettable but it is not closed." In a front-page *Gazette* editorial on December 15 titled "Not So Easily Closed," Marshall demanded further answers and a more complete state investigation.[14]

Others agreed. On December 26, Linn County attorney G.K. Thompson of Cedar Rapids announced that he was convening a grand jury to look into the Cooper case. Several weeks later, it indicted Cooper for violating the state liquor law, charging the commissioner knowingly and willingly permitted Farmer to possess liquor illegally, adding, "The only purpose the seals could have served was to cover up illegal possession."[15]

In the meantime, Cooper was losing the confidence of his boss, the Iowa governor. In a letter to Marshall, Herring asked the Cedar Rapids editor what he thought of Cooper. Marshall, as was his pattern, minced no words in his written reply to the Iowa governor: "When he gratuitously passes out the state's own seals to legalize a large assignment of illegal liquor at a time when publicity is given all over the state to prosecution of minor liquor law violations, Mr. Cooper renders himself completely impotent as the chief administrator of the commission created by the legislature to make the liquor business respectable.…I would have told Mr. Cooper to hand in his resignation or submit to his dismissal." By mid-January, Herring announced he had asked Cooper to resign and met resistance from the commission head. Cooper simply refused to go. The law creating the commission gave the governor the right to appoint the commissioner but not the right to fire him.[16]

That didn't stop Linn County from prosecuting the state liquor commissioner. Cooper's trial began in Cedar Rapids on Monday, February 11, 1935, with the prosecution led by county attorney Thompson. The trial was the central news story throughout Iowa, and every seat in the courtroom at the Linn County courthouse was taken—with many turned away. On the trial's third day, Marshall himself took the stand, repeating the statement he'd taken from Cooper over the phone on providing state seals to Farmer for bottles of illegally imported liquor from Wisconsin. Later that afternoon, Cooper took the stand and, under oath, denied saying this to Marshall, repeating his explanation that the seals were for liquor Farmer told him he'd had prior to Prohibition. Cooper argued that his actions were perfectly legal. In the eyes of Verne

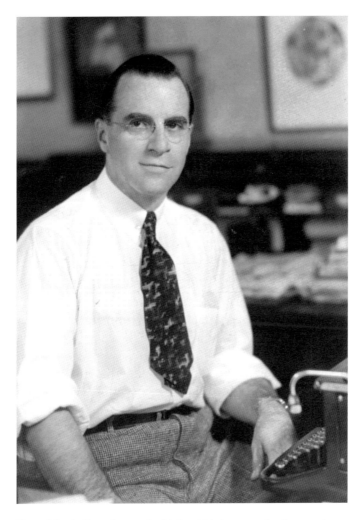

Verne Marshall was known for his hard-hitting exposés whenever he
saw graft and corruption, as well as his commentary carried in his
"Current Comments" column on the *Cedar Rapids Gazette*'s front page.
Courtesy of the Herbert Hoover Presidential Library.

Marshall, the head of the Iowa Liquor Control Commission had just
committed perjury; to the editor of the *Cedar Rapids Gazette*, this was not
the end of the story.

Thompson, summing up for the state, ridiculed Cooper for believing
that Farmer had kept all this liquor since before Prohibition. "Sending
of the seals was damning evidence Harold M. Cooper knew Farmer had
contraband liquor," Thompson said. "Cooper's duty, when Farmer told him

he had liquor, was to send a commission investigator to find out what there was to it, instead of sending seals to make the liquor seem legal when it wasn't....Farmer didn't need seals if his liquor was legal, but only to cover up illegal liquor."[17]

Others—including many in the state legislature meeting in Des Moines at the time—were also concerned about operations in the newly created liquor commission. On the same day as Cooper's Cedar Rapids testimony, the Iowa Senate—the galleries packed with the largest crowd of the session—passed a resolution calling for an investigation into the commission. Two days later, the Iowa House agreed. In addition to the Cooper affair, legislators were concerned about a state audit showing the commission had spent thousands of dollars unnecessarily, including liquor purchases at higher prices than standard market levels.[18]

On February 16, the jury in Cedar Rapids took only an hour to convict Cooper of violating the liquor law by allowing Farmer to illegally possess alcohol. Cooper was fined $1,000 and court costs. Still, Cooper refused to resign, saying that he expected to be vindicated on appeal, which his lawyers filed immediately with the Iowa Supreme Court.

By this time, results of Marshall's investigation from his sources on further illegal activities were already appearing in the *Cedar Rapids Gazette*. Ahead of the trial, on February 4, the newspaper carried a front-page story by Marshall: "Says Donations Asked on Liquor." The article charged that Iowa state senator Paul Schmidt, a Democrat from Iowa City acting as a liquor salesman for the Jo Daviess County distillery of Galena, Illinois, had been told by Democratic Party chairman E.J. Feuling that he was expected to pay sixty cents of every dollar he earned by the commission to the "Democratic campaign fund." Marshall wrote that, when presented with this question, Schmidt was initially reluctant to talk about the issue but freely admitted the exchange "after the source of information possessed exclusively by the *Gazette* had been revealed to him, and the uselessness or evasions was apparent." (Marshall had already collected information about the kickback request from the Galena distillery, which explained to the editor that it raised Schmidt's commission after he explained he was urged to pay into the "Democratic campaign fund.") Schmidt said he refused to pay money from his commission into the fund, explaining, "I don't do business that way." Feuling, editor of the New Hampton, Iowa newspaper, denied the charge. "It's ridiculous, it's a lie....As far as I know, no democratic campaign money came from commission on liquor sales."[19]

The Marshall story on campaign kickbacks from liquor sales to the Iowa commission prompted the legislative committee in Des Moines to call Senator Schmidt into its investigation. In his testimony, the Iowa City senator changed his story, saying that he himself made the offer to contribute part of his commission to the Democratic fund, but the payment was never made. In his front-page "Current Comments" column, Marshall launched a tirade against Schmidt. "Obviously, the senator is all crossed up or, for one reason or another, has decided that the only thing to do is let someone conclude that he either was talking in his sleep or lying when he told his employers [the Jo Daviess liquor company] and the *Gazette* he had been advised he would have to kick in on a campaign fund." The changing stories among state officials was getting too much for Marshall to take. He wrote a letter to the head of the legislative committee, Representative M.X. Geske, that Schmidt's "testimony was in violent conflict with his explanation told directly to me."[20]

Armed now with shifting and changing explanations from several state officials, Marshall continued to investigate the liquor sales story and discovered that the issue was causing tension among senior Democratic politicians. The dean of Iowa Democrats was U.S. senator Louis Murphy of Dubuque, elected in 1932. Marshall reported in a front-page story on March 15 that Murphy confronted Governor Herring at the Waterloo funeral of an Iowa highway commissioner last November. In "a heated conversation with the governor, in the presence of other prominent Iowa democrats," Senator Murphy charged that the Iowa liquor commission was not keeping with the spirit of the law. He said the liquor stores were selling to "known illicit dealers" who were reselling liquor at bars and that "the word was that they wouldn't be prosecuted as long as they bought from state stores." Murphy also said he had learned that one liquor company couldn't sell to Iowa unless it paid $400 to a state official, referring to Senator Schmidt, who lost his job as liquor dealer as a result of the conversation. Marshall reported that the Murphy-Herring conversation became "almost violent," as the U.S. senator told the state politicians to clean up their acts or face the consequences of angry voters. Contacted by Marshall about the confrontation, Senator Murphy said to the editor, "You have it quite straight."[21]

On March 19, another story about Cooper's misdeeds, written by Marshall, roared across the front page of the *Cedar Rapids Gazette*—this time dealing with election fraud in 1934. With the headline, "Cooper in Election Deal,'" Marshall revealed that Cooper, while liquor commission

head, had contacted a Democratic legislative candidate, J.H. Collins of Fonda, Iowa, after he had won his primary contest and offered him a job with the commission if Collins would withdraw. The plans, developed in discussions with party officials, including Iowa Democratic chairman Feuling, was to substitute another, stronger candidate to run in Collins's place. Cooper and Collins talked about the plan by phone, with Cooper essentially offering the candidate a job as a liquor checker within the commission in exchange for Collins's withdrawal. Collins turned down the offer and then lost the election. However, sensing that the request from Cooper was illegal, the candidate had a stenographer on the phone line who recorded the entire phone conversation, which was used by the *Gazette* as a source for the story. Marshall reminded readers that the Iowa Code prohibits such actions—offering jobs or money for public favors—by public officials, and the Iowa Liquor Control Act of 1934 states that any member or employee of the liquor commission who violates a similar provision "shall be deemed guilty of corruption." This article added to further pressure on Cooper to resign.[22]

From Cooper's perspective, this action was nothing more than normal politics. He testified before the legislative investigating committee that he had, indeed, offered Collins a $100-a-month job with the liquor commission if the candidate withdrew. And he made the offer at the urging of Chairman Feuling. That would not be the end of the story.

As March ended, the *Gazette* fully exposed J. LeRoy Farmer as anything but a "leading businessman" of Cedar Rapids. A front-page article by reporter Ray Anderson cited Farmer as the owner of the International Spirits Distributing Company of LaCrosse, Wisconsin. According to Wisconsin authorities, Farmer had tried the same trick in Wisconsin as he had in Iowa, getting state liquor seals for his bootleg liquor and passing it off as legal ware. He had illegally obtained more than one thousand Wisconsin liquor stamps "through misrepresentation," saying that these were for stock on which he had previously paid taxes. Farmer had also been evading taxes by concealing part of the stock and not reporting purchases and sales of certain brands. Local Wisconsin police began to uncover his operation, and the situation became so "hot" in LaCrosse that Farmer quit the city and set himself up in Cedar Rapids after Wisconsin authorities issued a warrant for his arrest. In Cedar Rapids, he had been selling illegal liquor, ranging from $45,000 to $70,000 a month. Farmer was certainly doing more than entertaining friends in his home with "pre-Prohibition" liquor. Admitting his crime, Farmer paid $1,000 in connection with the liquor raid.[23]

The information collected by the *Gazette* on illegal liquor sales, kickbacks and shifting and changing explanations by officials prompted Marshall and his staff to more fully explore these issues on a statewide basis. Expanding his effort beyond the eastern Iowa circulation of the *Gazette* was justified by Marshall because the focus was on the state government in Des Moines, which, he reasoned, affected his readers. His mission was to see if this graft and corruption the newspaper was uncovering led to state officials in Des Moines.

And the trail took him to the wide-open "bootleggers' paradise" in western Iowa—Sioux City.

3

THE TRAIL

Sioux City, Iowa, in the 1930s was approaching a population of eighty thousand, second only to the state's capital city of Des Moines. Located on the western Iowa border in Woodbury County along the Missouri River, Sioux City was at the crossroads of settled farmland and the expansive plains of western cattle county where law enforcement was lax at best—at least in such areas as liquor sales and gambling. For many in the city, that suited them just fine.

This attitude among residents was one reason the trail to statewide corruption led Verne Marshall to Sioux City. Marshall said later that he didn't care one bit about corruption in Sioux City, nearly three hundred miles from Cedar Rapids. It was the link from Sioux City to graft in state government that concerned him because that affected the rest of the state and the readers of the *Cedar Rapids Gazette*. For Marshall, Sioux City was not the end of the road but the trail leading to Des Moines.

According to *Des Moines Register* reporter Gordon Gammack, who spent some time in Sioux City for the newspaper in late January 1935 after liquor violations became news, Sioux City was a "bootleggers' paradise." He wrote, "This is a wide-open town where you can get a drink at any one of scores of night clubs, beer taverns and smoke shops. The quality of liquor ranges from the best brands from the state liquor store to the rankest stuff of prohibition days." Among those he interviewed, the general attitude was, "This whole Iowa liquor plan is a joke."[24]

Said one source, "Sioux City has always been a wet town. The people here and those who come here want to buy liquor by the drink. They are not satisfied to buy it by the bottle. This is a cattle town and we get farm men, traders, and ranchers from North and South Dakota, Nebraska, Minnesota, Wyoming and Montana. When they come here, they want to drink. And, no matter what anyone does about it, they'll do it."[25]

The source of that quote was Max Duckworth, the Woodbury County attorney, responsible for seeing that state laws were enforced.

The most conservative estimate of stores illegally serving liquor, according to Gammack, was one hundred. Others said that it was more like five hundred. Not only did liquor thrive in the city, but gambling did as well. One of the biggest gambling places was in the heart of the downtown district.

Testifying before the Iowa legislative committee on liquor in late February 1935, two local state legislators revealed investigations they had conducted on their own. At the committee hearing, Representative Gus Alesch (Democrat, Marcus) and John W. Moore (Democrat, Sioux City) produced a black bag and pulled out five pints of whiskey they had purchased at several Sioux City night spots the prior week in the early morning hours, in complete violation of state law. They named the establishments as Joe Siegel's bar, the Valley Garden, the Walnut Inn and the Peacock Inn. The latter was owned by Muriel Hanford, a former stage star known as the "peacock girl of vaudeville" and a former member of the Sioux City Junior League. The northwest Iowa legislators displayed their private detective work to show the investigating committee just how easy it was to buy illegal liquor in Sioux City.[26]

For Marshall, these tales of Sioux City lawlessness meant that someone was "on the take," collecting protection money to keep law enforcement from cracking down. And, to Marshall's way of thinking, this somehow had to lead to Des Moines. To begin to link these elements together, the editor contacted Ed Beck, a friend who was managing editor of the *Chicago Tribune*, to recommend a good private investigating agency from Chicago. Beck cited the A.G. Goodman Agency of Chicago. Marshall, together with C.J. Rasdel, vice-chairman of the code authority of the Alcoholic Beverage Wholesale Industry, hired an agent, W.H. Langley from the Goodman agency, and directed him to Sioux City. By March 3, Langley provided an initial report to Marshall and Rasdel, completing a second one on March 29.

Langley reported that illegal liquor-by-the-drink service was rampant everywhere in Sioux City. In virtually all cases, the investigator wrote in the March 3 report to Marshall, beer tavern owners paid their state fee of $100 a year (to sell only beer) and then paid local officials between $65 to $130 a

month for protection against prosecution. This included being allowed to sell whiskey and other liquor by the drink, operating illegal slot machines and having "any number of women about their places of business," meaning prostitution was part of the deal. Langley wrote that he had no difficulty getting whiskey in Sioux City, and "my chief difficulty was in disposing of the whiskey without drinking it." He also reported that the local media were bought off as part of the protection operation. Ed Forbes, the editor of the *Sioux City Journal*, "had a beautiful home on the hill, and he never made the money to pay for it working on the *Journal*." Also, the owners of the *Sioux City Tribune* possessed the building housing one of the city's major gambling operations at 511 Nebraska Street "and, for that reason, are not very likely to start any trouble." At that building, Langley wrote, "you can hear the announcer for the wire service plainly calling out the races. A crap game is in progress most of the time. The rear part of the main floor is used as a poker game." Slot machines, illegal under Iowa law, were found in practically every tavern and seemed to be doing good business, according to the investigator.

"With reference to prostitutes, or street walkers," wrote Langley, "I must say that never have I seen this profession (?) plied so openly." During one half-hour period, Langley said he was approached by no fewer than four women. "In conclusion, I desire to state that gambling, vice, and the sale of whiskey in taverns are practiced so generally and openly that it could not possibly escape the notice of anyone with normal intelligence."

But the most important item was found in Langley's March 29 report. He quoted Francis McGuire, Sioux City tavern owner, who alleged that Edward O'Connor, Iowa's attorney general, was in Sioux City several months before, drinking at a bar owned by Joe Siegel, a local gangster recently sentenced to prison for manslaughter. Langley reported that the attorney general was so drunk that he had to be carried out of the place and placed in Siegel's car.[27]

The trail for Marshall was leading somewhere.

Meanwhile, the state committee investigating liquor violations continued in Des Moines. Legislators heard testimony from out-of-state liquor salesmen that it was generally known merchants had to pay kickbacks to do business in Iowa. G.V. Middleton, a former salesman for a Louisville, Kentucky distillery, testified that it took a 2 percent kickback to Iowa commission members to sell liquor to the state monopoly. These accusations were met by denials from Iowa officials, testifying that they were misunderstood and certainly not involved in illegal kickbacks.

On April 2, 1935, Verne Marshall himself testified before the legislative investigating committee in Des Moines, making headlines across the state,

including in his own *Cedar Rapids Gazette* with a "Bares Sioux City Liquor Graft" banner blazoned across the newspaper's front page. Chewing gum rapidly as he looked up frequently to shoot quick glances at the legislative committee members, Marshall said that his investigation began with the Farmer raid in Cedar Rapids, during which he had "determined to reveal as many violations of the state liquor laws as we could find and prove," leading him to Sioux City. "Similar conditions exist in certain other cities of the state, but nowhere are they as recklessly rotten as in Sioux City," he said. Marshall charged that a graft payoff of from $15,000 to $20,000 a month goes into the pockets of local law enforcement officials there for protection money and that "some of this crooked money gets into the hands of certain people on the state payroll." In addition to protection payments for liquor violations, Marshall also raised the issue of the same system for illegal slot machine operations. In his public testimony, the editor also said, "I am prepared to name at least one Des Moines private citizen who is said to know everything there is to know about the Sioux City situation and who is cited to me as the man who takes care of the Des Moines end of the protection," linking thousands dollars of payments to those high in state government.

Marshall was open about hiring Langley of the Chicago Goodman Agency and laid out the information the investigator found, including the protection payments.

> *Payment of this crooked money provides protection for the sale of hard liquor by the drink in all beer joints that "go along" with the racketeers; for the installation of slot machines, of which several hundred are in operation; for the maintenance of brothels where liquor is sold by the drink and slot machines tinkle constantly; for just about every money-making violation of the law that is susceptible to the slimy manipulations of those who have organized crime in Iowa's second-largest city.*

As legislators listened to Marshall, they were richly treated to the reporter's own editorial commentary. Describing Langley's investigation and his background looking into Chicago crime, Marshall testified the investigator said of Sioux City, "Capone at the height of his power in Chicago never could have got away with such a racket as is being worked out there."[28]

Marshall reported that "state liquor commission agents are in it up to the hilt" and two Sioux City agents had already been fired by the commission's enforcement chief. He said Governor Herring was advised of the activities in Sioux City and had recently ordered agents of the liquor commission

to "help clean out the criminals there." This led to a recent raid on businesses in the town. Many shops, however, were warned in advance, charged Marshall, adding, "The tip-off came from a state employee who is not with the liquor commission." At the end of his testimony, Marshall then entered executive session with committee members to provide them with the names of the individuals involved in this crimes. The editor explained he didn't want to give names in open session, due to the potential costs of libel suits that might be filed by "those pug-uglies" as a means to disclaim their guilt. Based on his investigation, he gave the committee seventy-eight addresses around the state, in which he said state laws on liquor and slot machines were being violated.[29]

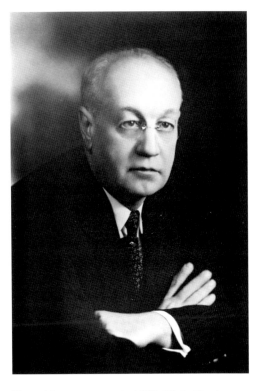

Elected Iowa governor in 1932, Clyde Herring guided the state through the depths of the Great Depression. After his meeting with Marshall in Des Moines in early April 1935, Herring told a meeting of Sioux City officials that "Verne Marshall has absolutely got the goods on you boys." *Courtesy of the Iowa State Historical Society.*

Governor Herring was not amused by Marshall's damning testimony of public graft and corruption that had been allowed to blossom in Iowa. Talking to a *Des Moines Register* reporter after the editor's testimony, Herring said, "If Verne Marshall has any definite information about graft in Sioux City, Ia., he ought to go to the attorney general of the state. He should go to the attorney general instead of spreading it out in the newspapers." The governor, however, also added in a later statement that day, "I pledge the full support of this office to a complete investigation of every charge made by Mr. Marshall and I welcome his help and that of anyone else who acts in good faith."[30]

The next day, thinking better of his critical statement of Marshall and probably hoping for an improved relationship with the aggressive *Gazette*

editor, Herring left his office and called on Marshall in his Des Moines hotel room to say that he'd been "misquoted" in the *Register*. In the privacy of his hotel room, Marshall unloaded on the Iowa governor the information that he'd been gathering the past several weeks. Marshall gave names, including several Sioux City officials whom he charged were involved in the protection kickbacks and tied in the elected attorney general of Iowa, Edward O'Connor. Much of the information Marshall passed on to the governor remained confidential, but it prompted Herring to call a meeting of the Sioux City law enforcement officials in his office the next day—April 4, 1935—and announce to them that "Verne Marshall has absolutely got the goods on you boys."[31]

The officials from Sioux City had been summoned to Des Moines by Attorney General O'Connor to, in his words, "co-ordinate law enforcement in Woodbury County," not suspecting that they themselves had Marshall's threatening finger pointing to them as lawbreakers. As Marshall's investigation proceeded, his editorial ire was linking a pattern of corruption pointing to the office of the state's chief law enforcement officer, Attorney General O'Connor.

Edward O'Connor was currently serving in his second two-year term as attorney general. Born in rural Johnson County, home of Iowa City and the University of Iowa, O'Connor graduated from Lone Tree (Iowa) High School and earned his bachelor of arts degree and certificate in education from Iowa in 1913. While a student, he won a Big Ten wrestling championship. He was superintendent of schools at Burt, Iowa, and served in the field artillery in Europe during the First World War. Returning home, O'Connor completed his law degree at the University of Iowa in 1920 and his doctor of law in 1923. His first political office was as attorney for Johnson County, where he served from 1923 to 1927 and was president of the Johnson County Bar Association in 1932. A Democrat, O'Connor unsuccessfully ran for Iowa's attorney general post in 1930; he tried again two years later, when Franklin Roosevelt's landslide victory helped Iowa Democrats sweep into all of Iowa's elected executive posts. O'Connor was reelected attorney general to another term in 1934.[32]

If there was a flaw in O'Connor's personality, it was his problem with alcohol. On election night in 1932, the newly elected attorney general was picked up in Des Moines on drunk driving charges. Thanks to the efforts of his attorney, Walter Maley of Des Moines, a grand jury was persuaded not to issue an indictment against O'Connor. According to Maley, his successful defense of his client prompted O'Connor to appoint the defense attorney

as first assistant attorney general, an action that would later play a major role in the statewide network of protection payments. There were other reports of O'Connor's drinking problems—and they would continue into the future.[33]

The meeting in Governor Herring's office on April 4 with O'Connor and the Sioux City officials—along with Marshall's testimony and other activities uncovered by the Iowa liquor investigative committee—prompted action in the northwest Iowa city. Woodbury County attorney Max Duckworth, who in Herring's office suggested a grand jury look into Marshall's charges, requested such action of district judge F.H. Rice. The grand jury was immediately assembled. On April 6, Duckworth announced that the first witness would be Verne Marshall.

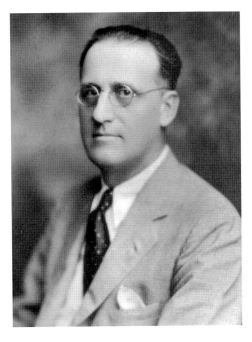

Edward L. O'Connor of Iowa City was elected Iowa attorney general in 1932, serving his second term in 1935. He became the centerpiece of Verne Marshall's corruption charges against protection payments for illegal gambling and liquor operations. *Courtesy of the Iowa State Historical Society.*

To the Cedar Rapids editor, getting those in Sioux City to clean up their town was nothing less than ridiculous, verging on criminal. Writing in the *Gazette* the same day as the meeting in Herring's office, Marshall said, "Consider, then, the prospects for a 'clean up' at Sioux City, or anywhere else, when the men called in by the governor to plan that cleansing process are men who have known for many months of the conditions they are supposed to cleanse, and have done nothing about it." In this case, according to the editor, the fox was clearly in charge of the chicken coop. Someone from the outside, urged Marshall, needed to change that.[34]

On April 8, Marshall traveled to Sioux City to give two days of testimony to the Woodbury County grand jury investigating public graft—and to conduct further interviews. On his first day of testimony, the editor wrote an essay explaining to the *Gazette* readers the reason for this journey. "One

thing is clear. It is up to someone to describe what is going on, so that the authorities here and elsewhere, including those in the state capitol, may have opportunity to take corrective action if they choose....Anyone who thinks the *Gazette* is trying to serve any but the public interest in delving into the Sioux City rackets as they spread out into other sections of Iowa either is misinformed, uninformed or just plain mistaken."[35]

It was at the end of Marshall's first day of testimony that his trail took its most interesting turn. At 5:00 p.m., Woodbury County attorney Max Duckworth visited Marshall in his room at the Warrior Hotel in Sioux City, and the conversation between the two, witnessed by Marshall's lifelong friend Robert Toms, lasted into the early morning hours of April 9. Duckworth probably approached Marshall to make sure his name was clean, but as the night wore on, the Sioux City attorney began to explain more and more of his involvement in the protection payments. Finally, under continuous questioning from the veteran reporter, Duckworth admitted at 1:30 a.m. that he—one of the chief law enforcement officials in Woodbury County—was receiving cash payments of $300 a month, a hefty amount in Depression-era Iowa. (Marshall threw a charge at Duckworth that the attorney was getting $1,200 a month. To that, Duckworth replied, "You're crazy; it's only $300 a month." Calling Duckworth a "sucker," Marshall said that the whole "racket" wouldn't work "if you weren't co-operating as county attorney, would it?" To Duckworth's answer "no," Marshall replied, "And you as a key man, get only $300 a month?") Duckworth said he was receiving payments from Sioux City bondsman Jim Pontralo, collected from operators in the city to buy protection from county and city authorities so they could continue to violate state and federal laws against the illegal sale of liquor and unlawful gambling operations. This information was only a reconfirmation of what Marshall already knew about Duckworth through his previous investigative digging.

The most important information passed on to Marshall from Duckworth, however, was the Des Moines connection. The Sioux City attorney named Joe Gagen, a Des Moines bondsman and shadowy figure with links to the underworld, as the go-between in the Sioux City–Des Moines association. (Like Duckworth's involvement, this reconfirmed what Marshall already knew; Gagen was the man referred to by Marshall as the individual "who takes care of the Des Moines end of the protection" in the legislative committee testimony.) Duckworth then named Walter Maley, first assistant attorney general of Iowa, as the man Gagen dealt with in Des Moines. At last, Marshall had a solid link from the Sioux City corruption network into

Attorney General Edward O'Connor's office. "Max," asked Marshall of Duckworth in the hotel interrogation, "this payoff racket is going on in other counties than yours, isn't it? Woodbury County is just one of the counties where Gagen works, isn't it?" Duckworth admitted that Gagen worked in other counties and that the graft network was statewide. At the end of the night, Marshall promised Duckworth that he wouldn't name him in the grand jury testimony if the county attorney kept his end of the bargain to battle corruption.[36]

The next day, April 9, the front page of the *Cedar Rapids Gazette* exploded with a headline, "Names Key Man in Graft Case" with a sub-head "Gazette Editor Reveals Go-Between at Sioux City Is Des Moines Man Now Missing." The story covered Marshall's testimony to the Woodbury County grand jury, which was carried by other newspapers across Iowa. Marshall named Gagen as the "go-between" in a statewide syndicate collecting protection payments in Iowa cities and counties for law violators in the liquor trade and slot machine operations. Not mentioning Duckworth, the editor cited V.W. Stephens of Sioux City as his source on Gagen (Stephens's name had been passed to Marshall by Sioux City attorney Ray Rieke, who testified before the legislative investigating committee with Marshall.). Stephens owned a publishing firm that printed baseball pool books, punch boards and jackpot books and had been contacted by Gagen, who wanted Stephens to pay $300 a month for the privilege of monopolizing the entire state with his materials. Stephens provided only one payment and then said he "grew sick of it." Stephens was one of the few merchants who would talk to Marshall about Gagen, and he was the primary source that led the editor to investigate Sioux City graft. Marshall wrote that Gagen had testified the previous week in the legislative investigation that he didn't know Stephens and had never heard of Stephens Printing. Wrote Marshall, "This writer knew as he listened to Gagen's testimony last Tuesday that he was hearing perjury, and that is one reason why the subpoena before the Woodbury County grand jury was so readily answered." Gagen, however, was missing from "his customary haunts" after Polk County deputy sheriffs in Des Moines began to look for him at 4:00 p.m. the previous day after "a discovery by the *Gazette* that Gagen had perjured himself." Marshall reported that Stephens then came to Des Moines to testify before the legislative to identify Gagen as "the man from the state." At the end of his explosive story, written before he was heading to testify to the Woodbury County grand jury, Marshall said, "And what a story Mr. Gagen could tell. I'd like to tell more of it for him, and I will do so a little later."[37]

However, Marshall *had* mentioned Duckworth's Sioux City graft involvement to the legislative liquor committee, which was revealed by the Associated Press and carried by the *Gazette* on its April 9 front page. The story cited Marshall's prior testimony in Des Moines to the legislative committee, naming Duckworth as "an official who was heading the organization selling protection in Sioux City." The information was released to the public by the legislative committee's attorney, who said that Marshall had also named nine other Sioux City men involved in the network. Duckworth's response was, "You may say for me all such charges are absolutely false," contradicting in public what he had told Marshall privately. He added, "Apparently I am being made a political target, though for what reason I am a loss to understand."[38]

Later that day, Duckworth met Marshall alone again at the Warrior Hotel, explaining that he had not come up with a way to link Woodbury County protection money to those in the Iowa statehouse without involving himself. Said Duckworth, "You know, Marshall, I haven't anything at all to do with about 99 percent of the racket, but the other 1 percent involves me so that I can't move or speak without being caught myself. I'm still trying to figure out a way to give you what you want about them [O'Connor and Maley in the Iowa attorney general's office]. I'm trying to play ball with you, but it's going to be a tough job to tell you what you want me to tell you without getting myself into a jam." Duckworth told Marshall that he thought Maley was the key man in the syndicate and that the county attorney thought, as Marshall later said, "O'Connor had been suckered in on this thing." On Gagen, Duckworth said, "He is the man that you will have to get the goods on."[39]

Duckworth was not the only person Marshall interviewed in his ten days in Sioux City. In fact, Marshall called for John Battin, managing editor of the *Gazette*, to come to Sioux City and, using the Warrior Hotel as their base, the two interviewed dozens of sources there over several days about the city's widespread corruption. One story Marshall later told was that he was threatened by an unnamed man with a gun in his hotel room; through a "skillful maneuver," the editor gained possession of the gun, eliminating the threat. Marshall never revealed the name of the gunman. By the time they had finished, Marshall and Battin had more than enough information to fill several newspapers.[40]

After calling several other witnesses to testify, the Woodbury County grand jury issued its report on April 17. Marshall's *Gazette* covered it with a blazing headline: "*Gazette* Charges Are Verified." Citing a widespread network of corruption and protection payments, the grand jury's main

thrust was to recommend removal of Sioux City commissioner of public safety Henry Kuhlmann. Members felt it would be useless to indict "petty employees" and "underworld" characters unless the responsible officers "without whose knowledge and connivance such conditions would not exist, are removed from office." In fact, the body issued no indictments at all, instead directing its wrath at Kuhlmann. He was charged with appointing an "inspector of police" who supervised the operation of the Sioux City racket, citing that as the basis for his removal. The grand jury concluded the chief of police was cut out of the loop and ordered not to conduct raids; instead, that task was left to the "inspector," who practiced it selectively, based on protection payments. This particular police network had one goal: "to facilitate the collection of graft money and to enforce, by prostitution of the power of the police, the collection of money in order to enjoy an immunity to break the laws." It further stated, "The open and notorious operation of places where liquor is illegally sold and consumed and where slot machines are in operation, even without other proof, leads to the conclusion such conditions could not exist without official knowledge and connivance."

The grand jury issued a feeble recommendation that "the public must demand enforcement of the laws on liquor and gambling," stating "there is abundant evidence of indifference and lack of intelligent interest" in enforcement, though it could find no evidence to implicate state officials. It also exonerated Woodbury County sheriff William Tice who, it said, had made an honest effort to enforce the law. On Duckworth, the grand jury said, "We feel that an injustice has been done by reason of sensational and unsupported charges and insinuations made through the press."

Marshall, however, knew otherwise. Sensing that Duckworth was not living up to his bargain of being honest with his involvement, Marshall shared his opinion on the Woodbury County attorney with his readers, coming close to revealing his confidential conversations with him. In an added commentary in the *Gazette* on April 17, Marshall wrote that Duckworth was the one public official "without whose cooperation the payoff system, the sale of protection for state and federal law violations, could not exist for five minutes. Mr. Duckworth will issue another denial, another protestation of his innocence when he reads this, but that will be meaningless, as both he and I know." [41]

And Marshall didn't stop there. The Woodbury County Board of Supervisors, with assistance from state district judge F.H. Rice, looked into Kuhlmann's removal and was considering appointing Duckworth as

the prosecuting attorney. On April 20, Marshall phoned Rice directly and strongly suggested Duckworth not be appointed. To the judge, Marshall said, "I will tell you this—I would just as soon be frank—Mr. Duckworth is a crook. I can prove it. I have the proof." Marshall continued, "If I were you, just to play it safe, myself, I would tell the board of supervisors that they must find another attorney to prosecute the case." Marshall ended the conversation with a suggestion that Rice call Duckworth into his office and "tell him that I just called you and said that you had better not permit Duckworth to prosecute." He inferred the attorney would understand.[42]

By the middle of April, the Iowa legislative committee investigating liquor improprieties ended its probe after calling more than fifty witnesses. Eventually, the committee would issue a report in early May only slightly critical of the Iowa liquor commission and calling for various recommendations on administrative functions—though it did call for ouster hearings against Cooper "as expeditiously as possible." This prompted Marshall in the pages of the *Gazette* to label it "the committee which pretended to investigate the liquor control commission and its administration of the liquor act," calling it a "whitewash" and

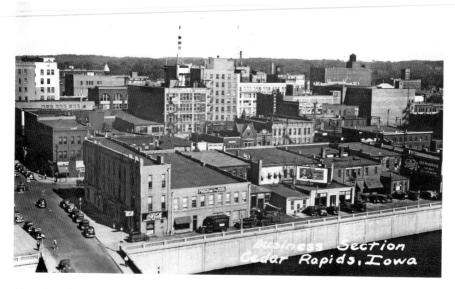

Above is a photo of the Cedar Rapids business section in the 1930s. The city was one of the largest in eastern Iowa, with a population of about sixty thousand. *Courtesy of the Cedar Rapids History Center.*

"a political tragedy, a nauseating example of political window-dressing designed to fool a gullible public."[43]

If the Iowa legislature wouldn't expose government wrongdoing and corruption, Marshall and his staff would. So far, the readers of the *Cedar Rapids Gazette* had not read all the information that Marshall and managing editor Battin had gathered in Sioux City and elsewhere. Beginning in late April 1935, they would experience a torrent of stories from the *Gazette* editor as he continued his series of exposés on the graft and corruption he had discovered through his intense questioning and investigations.

And the exposés would flow—day after day.

4

THE EXPOSÉS

On April 20, the *Cedar Rapids Gazette* readers saw a bold banner headline blazoned across the front page of the newspaper: "Gazette to Reveal Corruption." Two subheads immediately beneath read "Situations Similar to That at Sioux City Discovered in Places Least Suspected" and "Investigation Begun When Cooper Impugned Integrity of This Newspaper in Farmer Seal Incident Leads Reporters into Undreamed of Realms of Lawlessness."[44]

For the next several weeks, the *Gazette* readers were exposed to wave after wave of newspaper articles, most bylined by Marshall himself, that ripped off the gentle fabric of Iowa life and exposed an undercurrent of graft and corruption few in the state knew existed. At least, this was the world described by Verne Marshall, based on his investigation and reporting.

In the April 20 article, Marshall promised readers future stories by reporters who had "direct or indirect contact with lawlessness more vicious than even the most hardened reporter dreamed could exist in this state." Recalling Cooper's contradiction between his initial explanation to Marshall of Farmer bringing liquor into the state and his trial testimony that it was "pre-Prohibition" liquor, the writer said this launched his investigation. On Cooper's denial of perjury, Marshall wrote, "It so happened that this is one newspaper and one editor that refuse to take such a charge lying down." On the protection syndicate that shielded liquor and slot machine crimes, Marshall explained that he "set a trap" in his testimony before the liquor legislative committee. He had brought up in executive session the name

of bondsman Joe Gagen, who was then summoned to testify before the committee. "Gagen hedged and wriggled, forgot what he wanted to forget, remembered what he wanted to remember...the *Gazette* man [Marshall himself] was the only man in the room who knew instantly where Gagen was perjuring himself [denying that he knew V.W. Stephens of Sioux City and had collected protection money from him], and where he was not." Marshall wrote that the legislative committee "had little or no conception of the big game into which it was thrusting itself, unaware."[45]

Also on April 20, Verne Marshall dashed off a letter to Clyde Tolson, assistant to J. Edgar Hoover of the Federal Bureau of Investigation in Washington, D.C. This followed an earlier phone conversation the Cedar Rapids editor had had with the FBI official on the Iowa investigation and possible interstate ramifications of the corruption the newspaper was uncovering. In the correspondence, Marshall stressed that he was only interested in Sioux City because he was convinced the payoff money led regularly to the statehouse in Des Moines. "At this writing, I now am sure that it does, and beginning with today's issue, we are publishing a series of daily articles that should drive most, if not all, of the crooks out of the statehouse, and will do so."[46]

This was no idle boast. The stories continued the next day.

On April 21, Marshall wrote an article with the headline, "Raise $5,000 for Graft Proof," on a mysterious phone call he'd received while in Sioux City earlier in the month. The caller said that, if the *Gazette* could produce $5,000, Marshall "could be put in contact with witnesses who would produce every bit of evidence and testimony required to 'blast a lot of people out of Sioux City and Des Moines.'" While Marshall admitted he tried to raise the money, the caller made no further contact. In the same issue, Marshall brought up the name of Park Finley, who worked for Attorney General O'Connor as chief of the Bureau of Investigation, who was granted a sixty-day leave of absence two days after Marshall's Sioux City grand jury testimony, intimating there was a connection. The *Gazette*, wrote Marshall, interviewed Finley's sister, and she was evasive.[47]

The next day, the *Gazette* revealed that liquor commissioner Bernard Manley, one of two other officials serving with Cooper, had sent out letters on commission letterhead to Iowa liquor store managers in late 1934 to help them evade federal laws on liquor sales. The headline of the article was "Instructs Liquor Stores How to Evade Federal Law on Sales." Federal regulations limited stores to selling no more than five gallons of liquor to one customer. Manley's signed letter recommended that, if a customer wanted

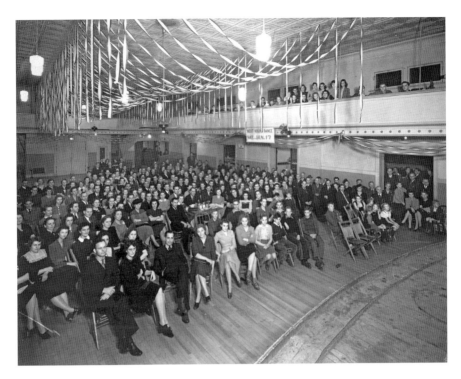

Verne Marshall was only the most prominent *Cedar Rapids Gazette* employee. Shown here are *Gazette* employees assembled for an employee gathering in 1935. *Courtesy of the Cedar Rapids History Center.*

to buy more than five gallons, the manager should sell it to him or her in separate transactions of fewer than five gallons each, technically falling outside the federal limitations. Contacted by the *Gazette*, Manley innocently said it was not his intention to avoid federal regulations. However, reported the *Gazette*, the federal commissioner of internal revenue had ordered a conference on this attempt to avoid federal regulations. The *Gazette* carried another story on the federal internal revenue commissioner's decision to order a conference on this attempt to avoid federal regulations. (Eventually, nothing came of this charge.)[48]

On April 23, Marshall cited proof that Attorney General O'Connor was at a bar in Sioux City owned by Joe Siegel, who had previously been convicted of manslaughter by shooting "another Sioux City gangster." With the headline, "O'Connor in Party with Slayer," the article described an evening at the Warrior Hotel in Sioux City where O'Connor was intoxicated, a fight broke out among others and police were called in; O'Connor was quickly taken out of the building. Marshall wrote of another incident at the Martin

Hotel in Sioux City where O'Connor was intoxicated. O'Connor's response in the next day's paper was that the story "is ridiculous, unwarranted and smacks of sensational journalism."[49]

Still more charges appeared the next day, April 24, when Marshall wrote a story on a $2,500 shortfall in the state liquor store in Sioux City. The deficit caused quite a problem within the commission's budget, and the solution by those involved with the liquor trade in Sioux City, according to the story, was to collect additional graft payments through the liquor protection network to make up for it. The "liquor sellers" were told that, if they paid the additional protection money, they wouldn't be interfered with by "the state." At the same time, however, Governor Herring had applied pressure on Sioux City law enforcement, particularly Sheriff William Tice, to clean up the illegal liquor trade, and the sheriff ordered raids on several businesses. This enraged several of the liquor establishments since this violated the agreement of being left alone. The additional money for the $2,500 was never collected through the "protection payments."[50]

Another item reported that day was a move on the part of a Polk County grand jury to investigate Harold Cooper's efforts to influence a local legislative election, brought about by the *Gazette*'s breaking the story earlier.

By April 25, Marshall wrote a strong editorial on the front page with the headline: "Cleanup Is Legislature's Job," carrying a subhead of "Gazette Asks Citizens of Iowa to Appeal to Their Representatives for Showdown on Political Graft." Wrote Marshall,

> *Wherever political or other dangerous crooks and weak public officials are, the finger of publicity is on them, and their political identities cut no ice with this newspaper. If they have betrayed their trust, knowingly or unknowingly, they must accept the consequences of such publicity as they are given here. After the* Gazette *has told the public the facts, its job is done. It is not a prosecutor, a grand jury, a governor or an attorney general; it is just a newspaper, trying to get along as such. If, after it has done its job, the public stands for the conditions revealed, that is the public's funeral.*[51]

To expand this point to a larger audience, Marshall directed a similar message to Iowans in a statewide radio broadcast on Des Moines station WHO.

The next day, Marshall openly called for the resignation of Attorney General O'Connor, citing his attendance at a party with Joe Siegel, "then and now under conviction as a killer," and the widespread graft stemming

from protection money paid throughout the state—particularly in Sioux City—and doing nothing to stop it. With rhetoric barely concealing a righteous rage, Marshall wrote,

> *Until the* Cedar Rapids Gazette *was compelled to start this investigation, following the perjury of Chairman Harold Cooper of the Iowa liquor commission, on the witness stand here in his own defense, nobody had made it his business to delve into the expanding gambling and other rackets in this state. But for the maladministration, malfeasance, misfeasance and worse on the part of Attorney General Edward O'Connor, who is at the very top of the law enforcement set-up in Iowa, the whole system of rackets that are thriving in this state could not do so for another day. It is within O'Connor's power to stop them all with one sweeping order. Why doesn't he do it? Let him answer that question in his own way, but the* Gazette *and its editor know the correct answer.*

The strong inference was that O'Connor was linked to the network of protection kickbacks, one that had intensified since the Iowa Democrats took power after the 1932 elections. "The slot machine gambling racket probably was not new in Iowa when the present administration took office," declared Marshall, "but it never has been as widespread nor as lucrative for its sponsors as at the present moment." Marshall wrote this editorial at the same time he sent a letter to the Iowa executive council—composed of all Iowa statewide elected officials, minus the attorney general—demanding a procedure leading to the removal of O'Connor from office.[52]

The first of victim of Marshall's assault fell on same day as the O'Connor editorial and letter to the executive council. Under intense and constant political pressure for weeks, Harold Cooper finally resigned as chairman of the Iowa liquor commission on April 26, 1935. His term of office would have extended to 1939, but he had completely lost the confidence of Governor Herring, who twice asked him to resign over providing state seals to Farmer in Cedar Rapids. The almost-daily editorial battering on Cooper from Marshall, no doubt, heavily contributed. Cooper's response was to blame attacks "by an unbridled press and by one of the professional muckrakers of Iowa who cared nothing about the facts or the truth." In a front-page editorial in the *Gazette*, "One Down—Plenty More to Go," Marshall wrote, "The *Gazette* has no illusions about where that shot was aimed, but it feels no necessity for ducking. This newspaper is not unbridled but it holds its own reins….If spending thousands of dollars and devoting a vast amount

of prodigious labor to disclosing corruption and officials incompetence is muckraking, if revealing how state and national laws are being violated and averted is muckraking—then the *Gazette* is a muckraker. And it is fully responsible for everything it prints."[53]

Marshall was certainly not finished, and on April 29, he opened an entirely new facet of state corruption coverage when he accused state officials of charging contractors extra money to bid on state purchases and services and placing this cash in a Democratic "campaign fund." Stating that he had "documentary evidence," Marshall wrote that "certain persons proceeded to build up the 'campaign fund' with contributions extracted from road contactors, cement manufacturers, and sellers of others supplied to the state itself, particularly of furniture and equipment." He revealed that for bridge construction, paving contracts, steel and lumber purchases and other building expenses, contractors were assessed up to 5 percent of their bid, and the money was passed to political operatives. Road contractors, Marshall claimed, were assessed 1 percent per mile. These assessments, wrote Marshall, "for political partisan purposes, were paid, in fact, by the taxpayers of Iowa." In an editorial in the middle of the front page with the headline "This Demands Drastic Action NOW," Marshall called for the state legislature to investigate these kickbacks, adding, "When the information the *Gazette* is now obtaining and authenticating is made public it is more than probable that certain impeachment proceedings will have to be instituted."[54]

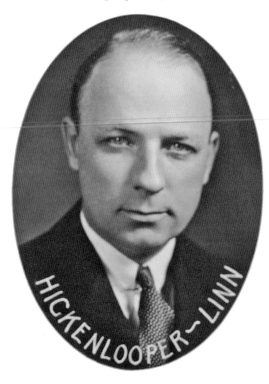

Iowa representative Bourke Hickenlooper, Linn County, aided Marshall in publicizing illegal state kickbacks from Iowa contractors. Hickenlooper later became Iowa's governor and longtime Iowa U.S. senator. *Courtesy of the Iowa Legislative Information Office.*

Marshall had a political ally in this effort in Linn County

Republican representative (and future Iowa governor and longtime U.S. senator) Bourke Hickenlooper, who used information provided by Marshall in a speech on the floor of the Iowa House on May 1 to denounce the political kickbacks in state contracts. Hickenlooper said he had evidence showing that:

- paving contractors who have taken state work at an average of about $25,000 per mile have been forced to contribute 1 percent of their contract to "leading and dominating members" of the Democratic Party,
- ten cents per barrel has been collected on cement used in state projects,
- as much as 10 percent from construction contractors has been exacted and collected, and
- lumber men and dealers furnishing other supplies have been assessed and bled with the regularity and determination that a certain percentage must be paid for the privilege of doing work for the state of Iowa.[55]

Hickenlooper introduced a resolution to investigate these charges but was voted down in the Democratic House. A similar bill failed in the Democratic Senate. The public argument among foes of the investigation was that the legislature would not be in session to report findings and, according to one Democratic representative, "We have courts to take care of things of that nature." The Iowa legislature adjourned without taking any action on the charges.[56]

Responding to the legislature's failure to act, Marshall wrote on May 3 in an editorial in the middle of the *Gazette*'s front page, "The Fight Is Not Ended," that this "by no means marks the end of the fight to rid the state of the corruptionists who have temporarily saved themselves from the fate awaiting them." Hinting strongly that he had additional evidence of statewide corruption, Marshall refused to simply turn over evidence to those involved in the graft. Calling again for the resignation of O'Connor, he demanded that Walter Maley, first assistant attorney general, leave office and added the name of Eugene J. Feuling of New Hampton, chairman of the state Democratic Party, to those who should "begin to contemplate the wisdom of resigning." Marshall also added to the list several officials in Woodbury County.

The *Gazette* editor proclaimed, "Let it be known here and now that the *Gazette* has completed its job of proving to the proper authorities that all the crimes listed above had been committed by those in and out of state and certain county offices." At the end of the long tirade against a range

of public officials and Democratic party leaders, Marshall, realizing that he'd been publishing a constant array of corruption charges, ended his long editorial with the phrase, "Let's just relax for a while," adding, "THE BRANDING IRON WILL BE KEPT HOT."[57]

Marshall did, indeed, relax for a while—in his own manner. He traveled on May 4 to the Elms Hotel in Excelsior Springs, Missouri, on his way to Hot Springs, Arkansas, for a vacation—of sorts. The trip also included a clandestine meeting with FBI agent Willard Peck and Ernie Carroll, special agent of the Kansas City Division, Intelligence Unit, Internal Revenue Service. The two federal agents had initiated contact with Marshall for further information about the illegal activities the editor was uncovering, and Marshall was more than willing to discuss details with them. During the conversation, Marshall made charge after charge, as if he were flipping through his notebook, throwing out names, misdeeds and general corrupt practices of all sorts. Among the information provided by Marshall:

- He cited information from William Lazere, Sioux City, who decided to get into the liquor business after Prohibition's repeal. At a liquor show in Chicago in early 1935, Lazere heard that there were some in Iowa already selling liquor to the state stores "if they would pay so much for the sale to Iowa, they could sell them." One prominent liquor agent told Lazere he was selling almost everywhere else but Iowa because he refused to pay off the grafters there.

- Marshall told another story from Lazere, revealing that the Continental Distilling Company of Philadelphia was selling $130,000 worth of its product to the Iowa Liquor Control Commission with the understanding that 5 percent would be paid to the Democratic "campaign fund." After the Cedar Rapids Farmer raid, said Lazere, "every one got scared on this liquor graft," and the sum was not paid.

- The editor cited information from George E. Lucas of Waterloo in Black Hawk County, currently a prisoner at the state penitentiary in Fort Madison, Iowa. Marshall said he was a key man in shipping illegal liquor into Iowa who sold $10,000 worth of liquor to the commission for $40,000. The plan was to split the $30,000 profit between himself, Chairman Cooper and two others, but they were slow in getting the money to Lucas, prompting him to forge a check, which brought him to the state penitentiary. Marshall

explained that he got a Black Hawk County official to bring Lucas to the *Gazette* office on his way to Fort Madison for an interrogation by the editor in which Marshall, in his words, "whanged away at him for two hours" to get the information.

- Marshall named a John McCormack of Marshalltown, Iowa, a nephew of Harold Cooper, who represented Seagram Liquor Company and was illegally selling liquor directly to Elks clubs around the state. Marshall also reported that McCormick was selling bootleg liquor in Iowa with state seals on the bottles, probably made at a printing plant in Milwaukee.

- Governor Herring did not escape Marshall's attention. The editor told the agents that he confronted the governor in a recent interview session with proof that he had income considerably larger than his official salary. "After a few moments hesitation," said Marshall, "Governor Herring said, 'Some of my friends are helping me with my living expenses while I am Governor.'" Herring named Des Moines residents Norman Wilchinski ($1,000) and Fred M. Hubbell ($650) as his "friends." Marshall quoted Herring as saying, "There are a lot of fellows being just that nice to me, and if it weren't for them, naturally, I couldn't hold this job and carry on as Governor."

- One of the more interesting characters Marshall discussed with the agents was Cornish Beck of Sioux City. He went bankrupt running the Beck Jewelry Company there and was hired as "contact man" for the Democratic Party, collecting money from highway contractors. Beck admitted to Marshall that he told contractors wanting state jobs that, if they wanted the Iowa contracts, it would cost them from $100 to $250, according to the magnitude of the contract. Beck would then advise them how much they needed to pay into the "campaign fund" and when, where and to whom they should pay. In most instances, said Marshall (quoting Beck), party chairman Feuling took the payments, but sometimes, payments were made directly to Governor Herring. Beck also visited businesses who sold cement to the highway contractors and told them they were expected to contribute ten cents a barrel to the "Democratic fund" on all cement sold to contractors. Marshall said Beck also contacted the Iowa State Gravel Men's Association and told them to contribute $2,500 to the "campaign fund" because of all the gravel they

would be selling for use on Iowa roads. The added payments also included kickbacks on automobiles, snow ploughs, tractors and other equipment sold to the Iowa Highway Commission. Added Marshall, "You always ought to get the 'Campaign Fund' in quotes, because, hell, it sure wasn't a campaign fund."

- Marshall described Beck as an ally of Harold Cooper, working for him on the Iowa staff of the New Deal's Progress Works Administration and then as manager of the Sioux City liquor store. It was under Beck that $2,500 in liquor merchandise went missing.

- Marshall charged that Governor Herring had collected money from the "campaign fund," arranged through attorney Will Reilly of the Carr, Cox, Evans & Reilly law firm in Des Moines. Said Marshall, "[T]his Reilly is the Governor of Iowa, in fact. Smart as hell, a money-maker. His best friends don't trust him. He is the Governor's right hand and his left hand. The Governor doesn't make a move without Reilly telling him what to do." Marshall said that liquor companies or contractors pay attorney fees to Reilly or Frank Comfort, another attorney at the firm; for instance, instead of a $500 fee, it might be $5,000. From this system, Marshall charged, Herring gets his cut.[58]

There is no record of the response Agents Peck and Carroll provided Marshall at the end of this extraordinary session in Excelsior Springs. But Marshall, in a letter to Guy T. Helvering, commissioner of the Bureau of Internal Revenue, seemed quite pessimistic about actually getting federal indictments against those he accused. "Mr. Peck seems to understand exactly what he is trying to do, but there is no more prospect of his achieving success along than there is of John Dillinger coming back to life."[59]

Hot Spring, Arkansas, it appears, was the common vacation spot in May 1935 of both Marshall and Iowa governor Clyde Herring, who—despite being the recipient of covert charges of corruption—shared dinner together at a restaurant there. Both the governor and the editor denied the meeting was anything more than a social affair; Herring even presented Mrs. Marshall with a bouquet of flowers. Asked about the dinner by a reporter, Marshall said, "My presence with Governor Herring at the same dinner table in no way affects my opposition to the crooks in the Herring administration….It will not in any way affect the *Gazette*'s determination to see that the crooks are kicked out of that administration."[60]

It would not be long before Marshall's reporting and the *Gazette*'s exposés would have an effect—and the "kicking out" would begin.

5

THE RESIGNATIONS

The resignation of Harold Cooper as chairman of the Iowa Liquor Control Commission was only the first head to roll as a result of Marshall's exposés and published investigations.

The next was Henry Kuhlmann, commissioner of public safety in Sioux City. Based on the recommendation from the Woodbury County grand jury, district judge F.H. Rice suspended Kuhlmann from his job on May 5, 1935, on charges of "malfeasance, misfeasance and non feasance in office." The commissioner would now have to show reasons why he should not be fired from his job.[61]

Another action by Judge Rice that day had more far-reaching effect. The judge ordered a new, second grand jury to further investigate the city's graft ring. Taking Marshall's advice against putting Max Duckworth in charge of the grand jury, Rice announced the appointment of two Sioux City attorneys—O.T. Naglestad and Carlos Goltz—as special prosecutors to assist the investigating effort. Naglestad had been Woodbury County attorney for sixteen successive years before retiring five years earlier, and Goltz had been chief defense council in several recent outstanding criminal trials.

The new prosecutors' first action was to present to the court affidavits by two Sioux City policemen who charged their hands had been tied by Kuhlmann when they tried to arrest gambling and liquor violators. One of the officers, Sergeant Joe Young, said he had repeatedly told Kuhlmann of the payoff system and had been warned by the commissioner that there are "certain persons in Sioux City who cannot be arrested." Still another

officer was told by a slot machine owner, "There are bigger men in this racket than there are on the Sioux City police department." Another officer said he told Kuhlmann of evidence of corruption but was never requested to produce it. Further testimony from other officers exposed threats against them, including job loss and physical force, if they arrested persons operating gambling machines.[62]

This second grand jury was about to get more ammunition for its investigation. On May 9, Sioux City police initiated several raids throughout the city, seizing slot machines and, more importantly, records at the businesses. These raids, ordered by Naglestad and Goltz, resulted in the arrest of four men and seizure of seventy-three slot machines. In addition, one document was found in a raid—later known as "the little black book"—that contained a listing of payments to a person referred to as "Duck." Nearly everyone hearing this knew that this referred to Woodbury County attorney Max Duckworth. Another payment reference was to "Luk," which many took to be Nile Luke, head of the Sioux City police raiding squad. In addition, the black book contained names of several other prominent Sioux City residents and a former police commissioner.[63]

Two days after the raids, Judge Rice ordered the two special prosecutors to file proceedings for the removal of Duckworth as county attorney. The judge cited Duckworth's involvement in the payoff and protection system throughout the city as the reason and suspended him pending a hearing for his permanent removal. Marshall's earlier conversation with Rice about Duckworth may have had an effect on the judge's decision. The two special prosecutors issued a petition alleging that Duckworth had been guilty of willful and habitual neglect and refused to perform the duties of his office, that he had been guilty of willful misconduct and maladministration and had been guilty of corruption in office. They declared he had also lost the confidence of the Sioux City police force.

In addition, Luke of the Sioux City police raiding squad was dismissed from the force on the basis that he was "guilty of corruption in public office."[64]

If there was any doubt about Duckworth's involvement in the Sioux City network, Verne Marshall cleared that up with his readers on May 13 under the headline, "Duckworth Shares in Payoff," with a subhead, "Tells Gazette Editor That He Received $300 Monthly in Racket at Sioux City." Marshall was now completely open about the conversations he had with Duckworth in his hotel room in early April, when the attorney admitted to accepting graft kickbacks. The editor withdrew his vow to Duckworth to remain silent because he felt the attorney was doing nothing to end corruption in Sioux

City. Marshall, in the story, also revealed that Duckworth had attempted to cut funds from Judge Rice's investigation and cited Duckworth's argument to the Woodbury County Board of Supervisors that they could not legally approve a second grand jury. This, to Marshall, was a direct obstruction to swift justice in Sioux City and all bets were off on keeping Duckworth's confidences secret.[65]

Marshall's ire was raised the next day when Attorney General O'Connor stepped into the Sioux City graft cesspool by saying the two special prosecutors were not qualified to serve, declaring that the county attorney—Duckworth—is required by law to name special prosecutors with the approval of a district judge. In this case, declared O'Connor, Judge Rice acted unilaterally and unlawfully. Rice obviously disagreed—pointing out that he had affidavits supporting the charges that Duckworth failed to perform the duties of his office, to say nothing of the "little black book" with payment references to "Duck"—and overruled the attorney general's request for the special prosecutors' removal. That set the stage for a fight before the Iowa Supreme Court.

In an editorial in the middle of the *Gazette*'s front page, "A Sorry Mess in Iowa," Marshall's words gushed forth: "Oh, it's a sorry mess we have in Iowa these days. Never before has this good old state had to tolerate the spectacle of an attorney general who associates with convicted killers, drinks himself into semi-consciousness, and, to cap the climax, rushes to the rescue of a crooked county attorney whose denouement easily might smear the attorney general himself."[66]

On May 15, two justices of the Iowa Supreme Court in Des Moines heard arguments on the issue. Representing the Woodbury County special prosecutors that day—Naglestad was home with a cold and fever and Goltz said to be "near exhaustion"—was an attorney who would play an expanding role in the prosecution of Sioux City and statewide corruption, former Iowa attorney general Horace M. Havner. He would become an uneasy ally of Verne Marshall. A native Iowan and graduate of the University of Iowa law school, Havner gained prominence as an outstanding trial lawyer. A stanch Republican, he served as attorney general from 1917 to 1921, gaining fame as a prosecutor of liquor violators in the age of Iowa prohibition. In addition, he prosecuted the infamous axe murder case in Villisca, Iowa, where twelve people were murdered in June 1912 and a famous Ida Grove rape case where Havner successfully initiated a suit to cancel a pardon handed out by an Iowa governor, proving fraud in the pardon's issuing. Havner was now practicing law with offices in his hometown of Marengo, Iowa, and Des Moines. One

reporter described Havner as "a bulldog of a man with a booming voice, who always wears a straight old fashioned collar in keeping with his almost ministerial attire." He would prominently display those traits in 1935.[67]

In the hearing before the supreme court justices, Havner read and filed an affidavit from Marshall, charging that Duckworth had confessed to the reporter that the county attorney had received graft payments. Duckworth vigorously denied the accusations as "untrue and false" and declared that the conversation never took place, adding, "Verne Marshall's motives need not be gone into at this time."[68]

The arguments of O'Connor and Duckworth failed to sway the two judges, and they denied the petition for a review of the special prosecutor appointments, forcing the attorney general and the Woodbury County attorney to drop their appeal. With the special prosecutors' roles upheld, the motions to remove Kuhlmann and Duckworth from office moved ahead.

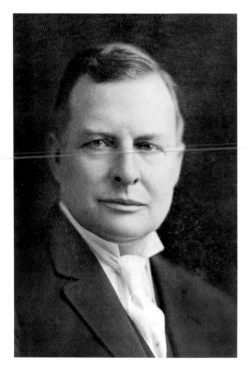

Horace M. Havner, Iowa attorney general in the late 1910s, was hired by the Woodbury County board of supervisors as a special prosecutor and tried another attorney general, Edward O'Connor, on graft charges. One reporter called Havner "a bulldog of a man with a booming voice." *Courtesy of the Iowa State Historical Society.*

Back in Sioux City, two policemen, Kirby Kerr and John Diebert, were fired and another, Tom Barron, was suspended. The first two were removed from their jobs for "corruption in public office," while the latter was suspended for misconduct and failure to do his duty.[69]

Meanwhile, on May 18, two other individuals who had gained the attention of Marshall were indicted by a Polk County grand jury on campaign violations uncovered by the *Gazette*. Harold Cooper, resigned liquor commission chair, was indicted by a Polk County grand jury for violating the state liquor act by offering a job to J.H. Collins in exchange for his withdrawal from a legislative race, revealed

by the *Gazette* in March. Also, E.J. Feuling, Democratic Party chairman, was indicted in Polk County for failing to report to the Iowa secretary of state office two $500 contributions from a Des Moines businessman. The indictment against Feuling came as a result of the *Gazette*'s series of articles and columns citing corrupt practices in state contracting. Marshall, in an essay, "Gazette Evidence Brings Results," took credit for bringing these actions to light.[70]

Several days later, Feuling pleaded guilty to the charge, claiming these were only "technical campaign violations" and was fined $500. In another front-page editorial in the *Gazette* written by staff member Harry Boyd, "Mr. Feuling's Change of Heart," Feuling's plea was seen simply as a cover up, hiding far more serious financial dealings between the Democratic Party and state contractors. If the case had gone to trial, contended Boyd, the larger case of graft payments to a campaign fund for state contracts would be laid out, something Democrats wanted to avoid. "Naturally, he [Feuling] was eager to have as little as possible become public knowledge."[71]

Three days later, Feuling resigned as Democratic Party chairman, directly blaming Marshall, the *Gazette* and others for unwarranted attacks "to discredit my party so that it cannot win the state offices in the 1936 elections." Writing in his newspaper, Marshall brushed it off, telling readers that the *Gazette* revelations and the evidence offered by Representative Bourke Hickenlooper on contracting kickbacks into the Democratic "campaign fund" prompted Feuling to travel to Washington, D.C., to meet with Postmaster General and National Democratic Party chairman James Farley to "save himself"—but to no avail. According to Marshall, Governor Herring himself decided that Feuling had to go, and the indictment clinched the chairman's resignation.[72]

And on May 20, Duckworth resigned from his county prosecutor job rather than face a hearing for his removal in Woodbury County. In his statement, Duckworth wrote, "I tender no apologies for not being a policeman." Marshall, in a story about the Duckworth resignation, repeated the attorney's confession that he collected $300 a month as protection money and his statements linking O'Connor and assistant attorney general Maley to the payoffs.[73]

The Duckworth resignation took place amid a tense atmosphere around the Woodbury County courthouse. On the day of the county attorney's resignation, a police guard was added to the courthouse, and a champion sharpshooter stood alert at the grand jury door. Other officers, both uniformed and in plain clothes, circulated throughout the lobby. Prosecutor Goltz was assigned a bodyguard, and wherever he went, three or four policemen were

at hand. The authorities were not taking chances against the hushed threats of violence circulating around the halls of justice in Sioux City.[74]

Further charges about the statewide graft payment syndicate came to light on May 21—this time through an Associated Press article—when Polk County grand jury testimony by Floyd Page, attorney for the legislative investigating committee on liquor, revealed a link between the Iowa attorney general's office and the payments. Page said that Tom Conroy, a Des Moines beer distributor, had told him that Edward O'Connor, then attorney general–elect, told Conroy in late 1932 to meet with Walter Maley, who linked him with Gagen, to lay the foundation for the alleged setup for collecting graft from slot machine operators all over state. The plan was to collect a dollar a machine per month from each operator, with Gagen as the contact man who would pass the cash on to Conroy. The money would be split four ways among this group.[75]

After this accusation was made public, Attorney General O'Connor issued a denial of ever calling Conroy to tell him to go to Maley's office for a meeting. O'Connor recalled first meeting Conroy at a Des Moines Elks Club meeting. Conroy later came to the attorney general's office, said O'Connor, "and intimated to me he wanted to arrange some 'protection.' I dismissed him from my office."[76]

The stakes were raised the next day when Walter Maley of the Iowa attorney general's office had Conroy arrested in Des Moines on extortion charges. Maley charged that Conroy had threatened to appear before the grand jury with conspiracy charges unless he was paid $200, a threat made to Maley in a letter from Conroy. Conroy, in his defense, said he was only asking to be paid back a loan he'd given Maley, even producing a canceled check. Maley, in turn, said the $200 was a fee for representing Conroy in court. The actual truth of the matter was unclear.

Maley's attitude toward Verne Marshall was not. After continually seeing his name in the *Cedar Rapids Gazette*, linking him with graft, corruption and a protection payment conspiracy, Maley venomously lashed out at Marshall in a media statement. Calling the *Gazette* a "character assassinating scandal sheet," the attorney raged at Marshall as an "accomplice" of the national and state Republican Party. Accusing Marshall of buying witnesses and interfering with the administration of justice, Maley wrote, "Marshall has done more than any man in the circle of my acquaintance to prostitute the courts of justice and the administrative heads of the state government." He concluded, "After all, a man has nothing in life except a character and reputation to sustain. I propose to sustain mine with all the force, vigor, and

vitality for which I have been known in the courts of this state. All those concerned may take notice accordingly."[77]

In a steamy editorial using two full columns on the front page of the *Gazette*, "This Account Is Not Settled," Marshall gave as good as he got. "As for the statement of O'Connor's first assistant, Walter F. Maley, concerning this writer, that statement can be most fittingly and conclusively answered by the terse assertion that Maley is a liar." Marshall wrote that the tirade against himself showed "the corruptionists in their true light, the low type that must be expected when such men as Attorney General O'Connor and Walter F. Maley dominate and control the state's department of justice. The attorney general and his chief assistant should be denouncing and prosecuting the crooks who have used the democratic party to line their own pockets illegally, and in so doing have wrecked all confidence in the present state administration, and especially in the law enforcement of the state."[78]

If he hadn't already, Marshall had now made a confirmed enemy of the number-two lawyer in the Iowa attorney general's office. It was interesting that this man had once studied to be a priest. Born in Manchester, Iowa, in 1893, Maley attended both Dubuque and Loras College, graduating from the latter in 1916. He obtained a master's degree from St. Louis University, where his interest turned to the priesthood, but he abandoned that for law school there. Moving to Des Moines, Maley established himself as a successful criminal lawyer, where he caught the eye of Edward O'Connor in 1932, especially after Maley helped clear the attorney general–elect of drunken driving charges. This act was rewarded by O'Connor when he made Maley first assistant attorney general.[79]

As May moved on, another official fell on the twenty-fourth when Henry Kuhlmann resigned as Sioux City's commissioner of public safety. In the Kuhlmann removal hearings, many among the more than forty witnesses who testified said they had paid money for protection to get law enforcement officers to look the other way. Sioux City resort owners were paying seventeen collectors as much as seventy-five dollars a month in Depression-era Iowa for the "privilege" of selling liquor illegally. One Sioux City policeman testified that he reported to Kuhlmann there were between three hundred and four hundred slot machines operating in the city; Kuhlmann told him to forget it because an American Legion convention was coming to town, and the Legion was getting a third of the cut. Finally, the overwhelming evidence was too much for Kuhlmann, and he announced he was quitting. In resigning, however, Kuhlmann denied knowledge of the payoff system and other graft.

Four days after Kulhmann left office, Sioux City police chief John McKenna submitted his resignation, replaced by new department head Earl Morgan, who declared a war on gambling.

The Sioux City story took another, more aggressive turn on May 27 when Woodbury County attorney Maurice E. Rawlings, Duckworth's selected successor, petitioned the court for the appointment of former Iowa attorney general Horace Havner as special prosecutor for the second Sioux City grand jury, replacing Goltz, who had resigned at the end of the Kuhlmann hearings. Appointed by the Woodbury County board of supervisors, Havner was given all the powers of a county attorney to examine witnesses before the grand jury and assist in prosecution of any indictments returned with reference to conspiracy, fraud, graft or corruption in public office. Rawlings made the request because he believed "the grand jury will be of far-reaching effect and possibly apply and pertain to many persons now in public office and many persons not living within this county." That would prove to be an understatement.[80]

With the appointment of Havner, an aggressive prosecutor with a statewide reputation and reach, the temperature of the investigation in Sioux City rose a notch. It was no longer simply examining crimes in Woodbury County alone. It was dramatically extending its reach throughout Iowa—into the highest levels of state government.

6

THE INDICTMENTS

Verne Marshall returned to Cedar Rapids from a six-week vacation in mid-June 1935, though he had written several editorials for the *Gazette* through this break. During his time off, his journalistic exploits resulted in the resignations of Kuhlmann, Duckworth and several policemen in Sioux City, as well as Feuling as head of the Iowa Democratic Party.

In a setback to Marshall's campaign against corruption, however, in early June, former liquor commissioner Harold Cooper was acquitted of charges of illegally interfering with an election by offering a job to a candidate in exchange for him leaving the ticket. Citing Cooper's action as simple politics, Polk County judge Russell Jones directed the jury to acquit, saying "the governor of Iowa might well have done just what Cooper did." If Cooper had urged the candidate to resign and support another, said the judge, the charge might stand, but that didn't happen. In the end, there was no influence because the candidate did not withdraw. "The court believes the criminal intent did not originate in the mind of the defendant." He also noted that candidate J.H. Collins had the conversation with Cooper recorded by a stenographer and transcribed, prompting the charge of entrapment.[81]

In Woodbury County, the arms of justice set in motion by the *Gazette*'s investigative series moved forward with the second Woodbury County grand jury, aggressively led by Special Prosecutor Havner. The body began calling witnesses from throughout the state, with the governor of Iowa, Clyde Herring, being one of the first to testify.

Before Herring traveled to Sioux City to testify, he was lambasted throughout the state in a public letter written by leading Sioux City businessman and Democratic contributor C.F. Lytle, published widely in Iowa newspapers. One of the wealthiest men in Iowa and among the Midwest's leading construction contractors, Lytle hurled charges against Herring's lack of action in the growing scandal, urging him to "drive out the political rodents who are endangering and destroying the Democratic party in this state." Writing that he knew of political kickbacks to the party's "campaign fund" by state contractors, Lytle said he "protested to Chairman Feuling against his methods of collecting or asking contributions from contractors and refused to have any part in 'shaking down' contractors." To Herring, he proclaimed the governor had "neither the intestinal fortitude nor inclination to do anything to assist in cleaning up a mess which is pointing toward Des Moines as well as Sioux City," adding, "Now, for God's sake, governor, prove, by doing something in this rotten mess, that you are a real governor."[82]

Herring's response to Lytle's written assault probably did not satisfy the Sioux City businessman when the governor spoke to reporters in early June outside the Woodbury County courtroom while waiting to testify before the grand jury. "As I understand it," Herring said, "they [grand jury members] are attempting to connect some alleged payoff in slot machine operations with some state officials." Saying he didn't think the grand jury could make these connections, he continued, "The last two years, I have heard such reports and always after my investigators have run them down, they have discovered that they were absolutely false." Herring's testimony of over three hours on Saturday, June 1, was closed to the public.[83]

After hearing from more witnesses, including Woodbury County sheriff Tice, the direction of the investigation was made clear on June 2 when Havner and Nagelstad requested that O'Connor, Maley and all members of their staff from the Iowa attorney general's office be prohibited from taking part in the probe. The *Gazette* reported that this was a result of information and testimony the grand jury had received indicting "participation of O'Connor and Maley in a system of protection payments by slot machine operators and gamblers throughout the state." Involvement of the Iowa attorney general's staff, contended the newspaper, "would be a travesty of justice and would endanger the validity of any indictments that might be returned."[84]

The action by the Woodbury County prosecutors was prompted by O'Connor sending assistant attorney general Clair Hamilton, a close friend of O'Connor, to monitor the grand jury proceedings. Hamilton had already agreed to withdraw from the courtroom when evidence was presented on

the attorney general. Now, the prosecutors were asking that Hamilton be barred from taking part altogether. From Sioux City, Hamilton charged the prosecutors with simply seeking publicity.

To Marshall, renewing his "Current Comments" column after his vacation break, this was another example of O'Connor's office obstructing justice. He wrote, "At no time has the attorney general's office made a single move to do other than impede the process of removing those crooked public officials from office. At no time has the attorney general's office indicated its possession of definite knowledge of the crookedness of other public officials in other counties.…It is difficult to get to the bottom of such corruption as exists in many parts of Iowa when officials sworn to uphold the law are among the most vicious and chronic violators of those laws."[85]

If the attorney general would not investigate graft payments to protect illegal actions around the state, Verne Marshall certainly would—or at least get others to do so. On June 14, the editor again directed the Goranson private investigation agency in Chicago to send an agent—in this case, F.M. Ephraim—to canvass Iowa in search of corruption, specifically the slot machine protection ring. In a letter to agency head A.G. Goranson confirming a phone exchange earlier that morning, Marshall wrote, "As you know, what I am especially anxious to learn, and must learn, is whether those who own the machines or those in whose places they were installed, paid any public official or anyone else who might have transferred the money to a public official for the privilege of permitting those machines to operate. What I am after is the payoff that goes into the hands of state officials in Des Moines." If Ephraim didn't dig up the information Marshall required, he concluded, the investigator was to receive no compensation outside of expenses.[86]

Ephraim spent the latter half of June moving throughout the gambling and drinking haunts of Iowa and reported his findings to Marshall weekly. Beginning in Ottumwa in southeast Iowa and traveling to Waterloo in the northeast part of the state without success, Ephraim heard one man to talk to was John Atwood of Perry in central Iowa. When Ephraim contacted him there, Atwood admitted to paying the current county attorney for protection, who, in turn, paid the local sheriff and, finding investigative gold, also paid Joe Gagen, known as the "state man." That was all ended now, said Atwood, "due to all the 'heat' that was on at Des Moines." Spending time in the resort towns of Spirit Lake, Arnold's Park and Lake Park in northwest Iowa, Ephraim coaxed an admission from a local justice of the peace that he believed there was a connection between local officials and the attorney general's office. The justice cited a conversation between himself and the

local sheriff who said he'd gotten a call from someone on the attorney general's staff, "asking how bad the local heat was around there." If it was too hot, the sheriff said, the person advised the sheriff to tell the operators to lay off for a while. There was little in Ephraim's report that would stand in the court of law, but that wasn't Marshall's primary goal. He simply wanted information.[87]

In the meantime, Attorney General O'Connor found new religion in a crackdown against slot machines. On June 17, he called upon county sheriffs and attorneys to cooperate fully with a special vice squad he had created within the state bureau of investigation. Saying "the attitude of some county officials has not been one of full cooperation in the past," he declared that era over. In his "Current Comment" column, Marshall called the action "grandstanding" and wrote, "That office has known right along of the corrupting operations of slot machines in this state." Only the recent revelations from the *Gazette*, he wrote, prompted his action, but he did not expect much with "the attorney general's office hopelessly disqualified by reason of O'Connor's presence as its chief."[88]

The Woodbury County grand jury meanwhile continued to collect testimony and information, including records from three Des Moines banks on Herring, Lieutenant Governor Nelson Kraschel, Feuling and Frank Conroy, Des Moines attorney and Democratic contributor. The body even subpoenaed Attorney General O'Connor's secretary, ordering her to appear before the jury with records over three years "concerning slot machines or the violation of the liquor laws in Iowa." And on June 26, the grand jury called Marshall before the body, though, like much of the rest of the testimony, it was confidential and unreported.[89]

What was very public that day was a scathing tirade issued as a public letter by assistant attorney general Maley, charging that Marshall and the *Gazette* had paid for the services of Havner and the former attorney general was simply a pawn of the Cedar Rapids editor, using the Iowa judicial system in a partisan Republican effort to discredit Democrats. The letter was also an attack on Sioux City businessman Lytle, whom Maley accused of being involved in corruption himself in his state contracting business; Maley described Lytle as a lifelong Republican who had only recently joined the Democratic Party. "Apparently," Maley wrote to Lytle, "your mode of self-promotion is to discredit and castigate all members of the party in power, which you have so recently joined."[90]

Marshall wearily wrote that "it is a waste of time to rely to a statement by Walter Maley," continuing his editorial assault on the *Gazette*'s front page:

Maley is annoyed because he thinks someone is paying someone else to try to get the facts before the Woodbury county grand jury whose delay in reporting indictments is a mystery to me. I happen to know that more than enough testimony has gone to that jury to justify at least a dozen indictments. And I know something of evidence. The Cedar Rapids Gazette is paying no attorney, H.M. Havner or anyone else, and has not promised to H.M. Havner a penny, but it has spent plenty of money to overcome the resistance of those who are doing everything in their power to hamstring this investigation. I regret that Mr. Maley is annoyed because most of the costs are being met by private parties—after the law enforcement authorities here and in the attorney general's office failed to do their duty—but Mr. Maley's annoyance today is mild compared to what it may be a little later on.[91]

Marshall's irritation with the slowness of the Woodbury County grand jury soon ended when the first wave of twelve indictments came tumbling down on June 30. The group included a number of Sioux City officials, including Thomas Taggart, Kuhlmann's predecessor as public safety commissioner,

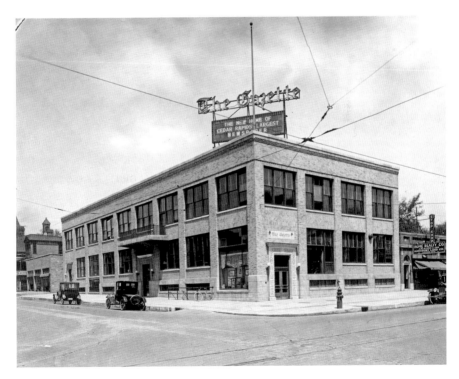

Shown is the Cedar Rapids Gazette building. *Courtesy of the Cedar Rapids History Center.*

and several illegal liquor and slot machine operators. An Associated Press article on the indictments reported that there was sensational testimony from a Jake Harkaway, lunch counter operator for beer parlor operator J.R. "Red" Brennan, stating O'Connor had been seen in the parlor on two different occasions after the 1934 elections where he drank illegal liquor at the bar and saw the slot machines operating. Harkaway also testified that Joe Gagen came by the parlor once a month.

The exposés by Marshall continued in dramatic fashion. The *Gazette* readers got a banner headline on the afternoon of July 1, "Letters Cite Protection Set-Up." In an article written by Marshall, he revealed the contents of letters seized the day before at the Fonda, Iowa home of Frank Brisbois, slot machine operator in several northwest Iowa counties. These letters, written by Max Langer of Dubuque, described a meeting of prominent slot machine owners in Des Moines in 1933. They laid out the protection program, calling for the operators to send in locations of their machines so they would not be seized by state agents. Those who paid protection money had "absolute assurance" they would be left alone. In another letter, Langer outlined a plan to raise $500 to finance the travels of state agents so they can "keep those items from appearing in the public records." "In the meantime," Langer wrote, "we are at liberty to proceed in our various territorial operational plans with the full and positive assurance that there will be no interference of any sort."

The letters, shown in the *Gazette*, were seized in a search warrant issued by N.T. Johannsen, a policeman from Sioux City. Marshall described his dramatic personal involvement in a flight from Sioux City to Dubuque in eastern Iowa with policemen in a plane owned by Sioux City businessman Lytle to deliver a subpoena to Langer. After arriving at the Dubuque home at 1:00 a.m., Langer's wife told Marshall and the authorities that her husband had gathered his office records and taken them to Wisconsin. Getting Langer's phone number from her, Marshall called Langer in Wisconsin, who said he would eventually accept the subpoena, but at the advice of his attorney, he would stay in Wisconsin. Marshall noted that Langer's attorney was Herbert Hoffman of Dubuque, Attorney General O'Connor's best man at his wedding.

Langer, however, reconsidered staying at his Wisconsin hideaway and traveled to Sioux City on July 1 to give his testimony to the Woodbury County grand jury. On the same day, Max Duckworth testified before the body. The former county attorney was promised immunity from prosecution for his testimony, a promise that would later hold uncertain credibility for Duckworth.[92]

The exposés by Marshall continued to burst from the *Gazette* the next day with a charge that LeRoy Rader, special assistant attorney general and former law partner of Edwin O'Connor in Iowa City, was a "fixer" for slot machine operators in northwest Iowa prior to his appointment, uncovered in the Brisbois letters. Several of the letters were written in the late 1920s from Rader to Brisbois, covering correspondence and personal contacts that the lawyer made in Brisbois's name to get local signoff on slot machine use in towns and counties. Rader was appointed to his current position with the election of O'Connor in 1932 and, wrote Marshall, "soon after that the slot machine racket began to work with the aid of state agents from the attorney general's office." This, according to Marshall, was growing proof that there was a link between the statewide protection syndicate and the attorney general's office in Des Moines.[93]

The crowning blow of Verne Marshall's assault against the Iowa network of graft stemming from Des Moines came on July 3, 1935. On that day, Iowa attorney general Edward O'Connor and first assistant attorney general Walter Maley were indicted by the Sioux City grand jury on charges of "conspiracy to operate gambling houses and gambling devices in Woodbury county in Iowa." They joined eighteen others whom the grand jury charged with conspiracy; among these were the dozen members of the Sioux City slot machine syndicate indicted the prior week. Calling it 'the most outrageous thing ever perpetrated," O'Connor added only, "I want to get a copy of the indictment before making any further comment."

The bad news for O'Connor continued. On the same front page of the *Gazette* announcing the mass indictments was a story—carrying no byline, but probably written by Marshall—of a charge that O'Connor had directly received protection cash payments in Des Moines from a northwest Iowa underworld figure, Bert Rollinger, currently serving time for extortion in the Iowa State Penitentiary at Fort Madison. Rollinger charged he had been contacted by Park Findley, who was then chief of the Bureau of Investigation under O'Connor and who had recently died. Rollinger said that Findley came to his northwest Iowa LeMars home in early 1933 and accused him of accepting payoffs for slot machines and liquor violations in both Woodbury and Plymouth Counties. Rollinger denied the slot machine charge but admitted he was collecting protection payments from bootleggers and was still operating. Findley said he wanted to make a deal with him, and after another visit from Findley, Rollinger agreed to pay $750 for state protection for his own beer operation but didn't want to pay it to Findley. Rollinger said he went to Des Moines in April 1933 and met Findley at the

Hotel Kirkwood, insisting that he be put in contact with O'Connor. After a few phone calls, O'Connor came to the hotel, and Rollinger paid the money directly to the attorney general with the understanding that Rollinger's slot machine and bootlegging protection collections would be approved by the state as well as his own beer-running. According to Rollinger's story, O'Connor was outraged at being asked to collect the money directly, saying to Rollinger, "Well, I know you are just a bootlegger, and if you ever say anything about this, you may be sure that I will ride you in the penitentiary so far you will never get out."

At best, Rollinger was a man of dubious background with a history of drug and alcohol abuse. As noted, he was serving time on an extortion conviction, though he claimed he'd been framed. He had been involved in collecting protection money for slot machine protection through Clyde Mayer of Sioux City in 1932. Beginning as an agent for bootlegger protection, Rollinger collected money from those selling illegal liquor, keeping 10 percent and passing the rest on to federal Prohibition agents in the region who agreed to look the other way. Through Mayer's businesses, he expanded into slot machine protection. Collecting nearly $3,000 from Mayer, Rollinger reached deals with the federal agents in which they would tell him of raids in advance and Mayer's employees would hide the liquor and the machines.

After he was sentenced to prison, Rollinger said he'd been promised money for attorney fees from Mayer and never received the cash. Choosing another route, he then sent a letter to Verne Marshall, who interviewed Rollinger about the O'Connor payment story at the Fort Madison penitentiary earlier in the year, taking the story from the prisoner and splashing it on the front page of the *Gazette*.

In still another story on the front page of the *Gazette* on July 3, the newspaper charged that Brisbois, the multi-county slot operator in northwest Iowa counties, had received advanced warnings on state raids directly from the attorney general's office through Joe Gagen. The source of the story was Pocahontas County attorney A.C. Carmichael, who had gotten the information directly from Brisbois, a very talkative and agitated operator because his cash protection agreement with Gagen had been breached. A state agent had recently gotten a search warrant for only one raid in the Pocahontas County town of Rolfe, and the local constable wanted to know why he wasn't raiding others in the county. The constable was so insistent that the state agent acquired search warrants for the other operations, including those of Brisbois, who thought he was protected through the money he paid Gagen. Brisbois complained to county attorney Carmichael, who was irritated because he'd been told that county attorneys would be consulted prior to these raids. Carmichael took it up with LeRoy Rader, special assistant

SECOND AVENUE~CEDAR RAPIDS, I.A.

Cedar Rapids had a busy downtown in the 1930s. Shown here is a photo of Second Avenue, pictured on a postcard. *Courtesy of the Cedar Rapids History Center.*

attorney general in Des Moines, who said these matters were usually handled by assistant attorney general Clair Hamilton, who was also O'Connor's former law partner. After this phone call, Brisbois then used the county attorney's phone to call Gagen in Des Moines to complain about the mixup, linking Gagen and the protection racket with the attorney general's office right in front of a county attorney, who passed the information to the *Gazette*.[94]

All in all, the *Gazette*'s July 3 coverage on O'Connor and his staff was not good.

Inside the Sioux City grand jury courtroom on July 8, northwest Iowa businessman Clyde Mayer provided five hours of testimony as part of an agreement to turn state's evidence in return for immunity from prosecution, giving a broad perspective on the Iowa protection system. Cross-examined by both Havner and Goetz, Mayer asserted it was generally known that the slot machine deal was engineered by assistant attorney general Rader. Shortly after Iowa Democrats took over state government in January 1933, said Mayer, there was a meeting of about twenty-five slot machine operators in Des Moines in which all agreed to pay one dollar a machine per week for protection from state prosecution. Bondsman Joe Gagen was designated to collect funds from slot machine operators around the state—in cash, not checks—that also protected illegal liquor sales, and he also agreed to work with local city police units to make sure they understood the system and didn't initiate "unauthorized" raids.

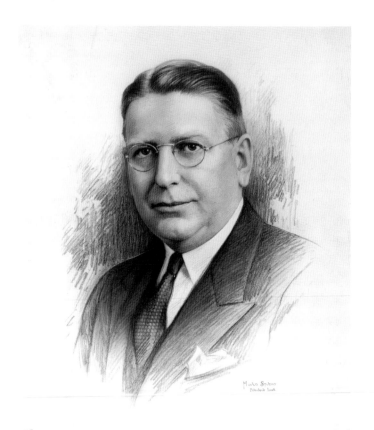

Nelson Kraschel of Harlan, Iowa, was elected Iowa lieutenant governor in 1932 and governor in 1936. Verne Marshall frequently linked him to graft payments and vigorously opposed his elections. *Courtesy of the Iowa Legislative Information Office.*

The group met several times, including one meeting with Gordon Hollar, Sioux City chief of police, who was also receiving direct payments. Hollar was there to help "iron out the trouble we had," according to Mayer; this "trouble" was territorial conflicts in the Wild West atmosphere of Sioux City around January 1934 among liquor and slot machine interests, resulting in bombings at stores. Gagen, according to Mayer, played a major role in easing tensions among these warring Sioux City gambling factions.

The result of this agreement among the Sioux City parties was that Clyde Mayer was cut out of the Sioux City slot machine business. His brother, John, knew Lieutenant Governor Nelson Kraschel, a Democrat from Harlan,

Iowa, elected in 1932 along with the rest of the Iowa Democrats, and set up a meeting between Kraschel and his brother in a Harlan restaurant in late 1934. There, Clyde Mayer explained the slot machine and liquor protection syndicate, how payments were made and how he'd been cut out; the lieutenant governor said, "I will see what I can do." Later, in a second meeting in Des Moines, Kraschel told Mayer, "Now I want to know from you what you think a deal like this is worth; what you could afford to get from fifty machines in Sioux City." When Mayer suggested $1,000, Kraschel replied, "Oh, it will take more than that. We couldn't handle it for that. Twice that much." Kraschel said he would look into it and said, in Mayer's words, "The gang you are playing with, it ain't none of my business, but if you call that a political set-up, I believe what few friends I have got can give you more assistance than the fellows you are dealing with." (Kraschel was not indicted through this testimony, said Prosecutor Havner later, because he could not be indicted solely upon the testimony of a fellow conspirator.)[95]

A week after Mayer's testimony—and using evidence from more than one hundred witnesses—the hardworking Woodbury County grand jury struck again. They issued forty-five more indictments, including ones for state agent C.W. McNaughton and Sheriff Ralph Rippey of Plymouth County, with the Sioux City liquor and slot machine investigation. (Many of the forty-five indictments were for those who had already been charged.)

The next day, the *Gazette* exposed the Mayer testimony to the grand jury with the headline, "Names Kraschel in Slot Setup." The story uncovered Clyde Mayer's testimony about Lieutenant Governor Kraschel's agreement with the slot machine operator to attempt to intervene for him in the protection syndicate. In an editorial in the middle of the front page, "More Indictments Are Needed," Marshall wrote, "Rarely, if ever, has Iowa been so defenseless against corruption as now. With a department of justice whose bureau of investigations is rotten to the core and from the top down, where can the people turn for enforcement of the laws?" Writing that O'Connor and Maley "have done more to wreck law enforcement in this state than any other two men possibly could have done," Marshall said, "They have sought to intimidate those who might have aided in exposing the crooks." Marshall cited the example of the late state investigator Park Findley "who knew altogether too much about the crookedness that had infected the state department of justice." When the *Gazette* made its charges to the legislative committee investigating liquor, Marshall claimed O'Connor announced Findley, his chief investigator, had gone to California for a sixty-day leave of absence for health. He didn't, contended Marshall. Instead, Findley was taken to a private sanitarium in Des Moines for four days and then shipped to

San Antonio. Wrote Marshall, "The *Gazette* has the Findley story now, and it will be revealed when and where it could do the most good."[96]

The assault on Woodbury County officials continued when new county attorney Maurice Rawlings announced on July 13 he would begin ouster proceedings against Sioux City mayor W.D. Hayes, based on a charge from Havner and the grand jury that the mayor neglected his duty to stem the rampant corruption in the city. Hayes's response was that he had violated no law, had served the people of Sioux City to the best of his ability and had no intention of resigning.

All this activity resulted in rising expenses for the prosecutors' efforts in Sioux City and Woodbury County, both of which were cash-strapped in Depression-era Iowa. As a result, Verne Marshall, as well as his ally, Sioux City businessman C.F. Lytle, supported Havner financially behind the scenes, an effort that would eventually severely damage the editor's crusade against Iowa corruption. However, all was not well between the *Gazette* editor and the former attorney general, two sizable, hard-headed egos. In a letter to Lytle on July 16, Marshall wrote, "Our expenditure in this campaign already have been beyond all reason, and I do not intend to let a long-winded, self-promoting lawyer [referring to Havner]—no matter how good he may be as a prosecutor—promote himself in the public eye while sticking me for the funds with which to do it." He added, "I was perfectly willing to help keep him going as a special prosecutor aiding the grand jury, but on the day I learned he was posing as the man who had dug up all the information that grand jury was getting, I was definitely through with him. This is by no means because I care for any of the credit, but because I can't tolerate that sort of man."[97]

The editor's patience was at an end in second letter to Lytle on July 23 when he wrote that he wanted "nothing more to do with Havner's Sioux City circus." Marshall added that Havner's "stubborn insistence on breaking into print, interviewing himself as the one who is most responsible for this whole blowout, has disgusted me sufficiently to divorce me from his Sioux City activities. If you want to continue to be his Santa Claus, that is your business." The financial cord was severed, but, as future events would show, the damage had already been done.[98]

Marshall, however, was not alone in voicing criticism of the Sioux City activities. On this other side of the divide, those accused and indicted—as well as Sioux City citizens, fearful of their town's damaged reputation—were fighting back.

The backlash was beginning.

THE BACKLASH

The whirlwind of indictments from the very active second Woodbury County grand jury and the statewide coverage generated by Marshall's *Cedar Rapids Gazette* and other media were negatively affecting Sioux City. The publicity surrounding graft, corruption, illegal gambling, protection payments and widespread liquor law violations cast Sioux City among Iowans as a town to avoid.

This sullied reputation was not one Sioux City citizens wanted their city to have, especially among business leaders seeking to attract Iowans there to spend money. By midsummer 1935, those leaders began to fight back.

On July 22, Governor Herring received a petition from seventy-three Woodbury County professionals and businessmen protesting the indictments as politically motivated and demanding Herring conduct an investigation. They were particularly incensed with the recommendation from Havner and the county grand jury to oust Mayor Hayes, believing that the special prosecutor and the body acted "wholly beyond the power or jurisdiction" of their positions. These actions and others, the petitioners stated, were disrupting "the work which has been initiated in behalf of the inhabitants of the city and has impaired the governing machinery and worked great harm to the welfare of its inhabitants." The petitioners inferred Havner and the grand jury were greater lawbreakers than those they indicted. By early August, Herring had received two other petitions signed from similar groups within Sioux City, putting pressure on him to act.[99]

On August 5, the Iowa executive council—composed of the governor, state auditor, secretary of state, state treasurer and secretary of agriculture—authorized O'Connor to appoint a special assistant attorney

general to investigate the Woodbury County grand jury on alleged corruption. Interesting enough, writing in the *Gazette*, Marshall supported such an investigation. "A real and purposeful investigation by an honest and fearless special assistant attorney general would be of inestimable value to this state," he wrote.[100]

From Sioux City with his job under assault, Mayor Hayes himself charged there was a conspiracy to remove him from office—led by Lytle, Havner and Marshall. Lytle and his paving company, said Hayes, were facing several lawsuits from the city for refunds on work that allegedly violated specifications and, by removing the mayor from office, the businessman and his firm were hoping for lawsuit dismissals or settlements on better terms. Hayes asserted that Lytle hired Marshall as a "paid publicist" to "deceive the public into the belief that the city government of Sioux City had utterly broken down and that there was a condition of lawlessness existing which called for the investigations in Sioux City." Havner, the mayor charged, was called in to assert "improper influence upon said grand jury."[101]

To these charges, Marshall wasted no time in responding. Accompanying the story on Hayes's accusations, Marshall wrote in bold typeface on the *Gazette*'s front page on August 7, "Whoever says or implies that the services of the *Cedar Rapids Gazette* and myself were engaged to clean up official graft in corruption in Sioux City is a deliberate liar….The *Gazette*, on its own initiative, showed up the crooks in Sioux City simply because their operations were related to those of crooks in other parts of the state. And no one invited or paid it a penny to do so." Havner said he himself, rather than the mayor or the state executive committee, would investigate charges of "political motives" and that anyone who knew of "false testimony" or "paid witnesses" in Woodbury County should contact him.[102]

That didn't dissuade the state executive counsel from acting. On August 8, Attorney General O'Connor appointed Maurice J. Breen, a Fort Dodge attorney, as special assistant attorney general to investigate the Woodbury grand jury. Breen announced he was "only interested in finding out whether complaints of political motives and purchased testimony made by Sioux City residents can be supported by the evidence." In announcing the appointment, O'Connor declared his office had heard that large amounts of money through private parties had been offered to individuals to sign affidavits and give testimony. He cited one individual who was willing to pay $5,000 for the procurement of witnesses before the grand jury. This charge was obviously aimed directly at Verne Marshall, who responded quickly in

the *Gazette*. Yes, wrote the editor, the offer of $5,000 was made to a man for information who never delivered. "Neither the *Gazette* nor anybody else of whom I have any knowledge, ever has paid a dime for any testimony or evidence in connection with this exposé of official and political corruption. However, it would be perfectly legal for any private citizen or anyone else to pay for proof of official crookedness in this state." Marshall added that "Mr. Breen is invited to dig into every source of this paper's revenue."[103]

Havner and the Woodbury County grand jury showed they could wrestle with statewide officials at their own game. As Breen began setting up his office in Sioux City to begin his investigation, the special prosecutor and the grand jury announced that they would, in turn, probe the Iowa state executive council for violating the Iowa Code through obstruction of justice. Soon, subpoenas flew from Havner's office for members of the executive council and staff, including Governor Herring and his secretary. After conferring with his attorney, Governor Herring declared himself immune from testifying, saying, "I can't be running up to Sioux City every time they have something they want to check with me."[104]

Others in Sioux City agreed that a state investigation of their local grand jury was simply a bad idea and that it interfered with the regularly functioning tools of justice. A counter-petition signed by four hundred Sioux City residents and sent to the state executive council said the investigation was "an insult to the intelligence of every citizen of this state" and asked the council to withdraw the special assistant attorney from Sioux City. Likewise, the Sioux City Ministerial Association denounced the state's investigation, terming it a "travesty of justice."[105]

State auditor C.W. Storms, after responding to his subpoena by coming to Sioux City and testifying before the Woodbury County grand jury about the executive council's action, returned to Des Moines to recommend the council "immediately consider" the Woodbury County grand jury's request to end the probe. State treasurer Leo Wegman spent a stormy closed session on Saturday, August 17, testifying in Sioux City, clashing with Havner with verbal fireworks during the questioning; the exchanges were loud enough to be heard in the corridors outside the grand jury room.[106]

Given the resistance by some in Sioux City and especially the treatment state officials received at the hands of Havner and the Woodbury County grand jury itself, the executive committee on August 20 decided it had had enough and unanimously decided to end Breen's investigation. That, however, was not the end of the affair. Two days later, the grand jury in Sioux City indicted Treasurer Wegman on perjury, based on a technicality during his

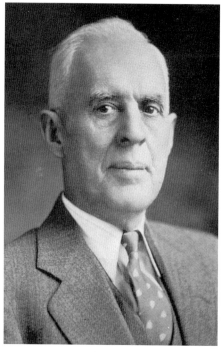

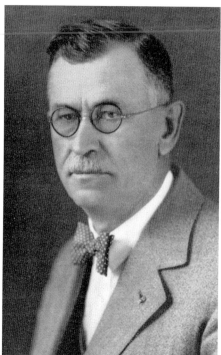

testimony on when a specific affidavit had been submitted to the executive council. Wegman took this in stride. "I said that those concerned might investigate to their heart's content and, if they wished, to take three running jumps and go to hell."[107]

The indictment of the state treasurer in late August came along with others, including further charges against more Sioux City residents operating gambling houses and an expanded number of charges against Walter Maley and Ray Harrison for obstructing and interfering with justice. Also indicted was Plymouth County sheriff Ralph Rippy for accepting a bribe. These marked the last of the indictments issued by the Woodbury County grand jury, indictments that shook the political establishment of the state of Iowa; in all, it had issued twenty-six indictments against forty-nine individuals. All of

Top: Iowa state auditor C.W. Storms recommended the state executive council end its investigation of the second Woodbury County grand jury after testifying before the group. *Courtesy of the Iowa Legislative Information Office.*

Left: Iowa state treasurer Leo Wegman clashed with special prosecutor Horace Havner while testifying before the second Woodbury County grand jury. When indicted, Wegman told the body to "take three running jumps and go to hell." *Courtesy of the Iowa Legislative Information Office.*

those indicted were beginning to work together to get the indictments quashed through legal maneuverings—with one major exception. The most high-profile defendant, Attorney General Edward O'Connor, wanted his trial to move ahead quickly, so he could get it out of the way before the 1936 elections.

The others accused, however, were fighting tooth and nail to avoid a trial or at least to make one difficult to prosecute. Maley, for instance, let it be known by late July that he planned to subpoena every peace officer in the state, about 2,500 individuals in all, to testify on his behalf. He planned to ask them, "Did Walter Maley ever ask you to 'lay off' prosecution of slot machine cases?" and "Did Walter Maley ever refuse to assist you if and when you asked him for help in stamping out slot machines?" It was obvious that convicting Maley would ignite a state trial of great expense.[108]

The sound and the fury of the Iowa corruption charges and the investigation by Marshall and his staff at the *Cedar Rapids Gazette* gained national attention in late summer when the story was featured in *Editor & Publisher*, the authoritative national journal covering the U.S. newspaper industry. Featuring photos of both Marshall and managing editor John Battin, the story roared with the headline "Iowa Daily's Drive on Liquor Graft Stirs Entire State—50 Indicted." The coverage was generally positive toward Marshall and the *Gazette*'s effort, beginning with the December 1934 liquor raid and taking the reader through the Sioux City investigations and the recent indictments. Obviously using Marshall as its main source, the article quoted the Cedar Rapids editor in its conclusion as he issued a challenge to the industry. "Whatever you call it, this state and nation might have fewer crooks in power, and, incidentally, fewer people suspicious of all forms of government and public officials, if there were more newspapers that printed the truth as they know it about such things as have come to light recently in Iowa." This would not be the last time the *Gazette*'s efforts would spawn national publicity.[109]

By mid-August, attorneys for those indicted—both from northwest Iowa and Des Moines—challenged the charges and asked they be set aside, maintaining that Special Prosecutor Havner was not legally empowered to present evidence to the grand jury because he was paid by two private parties outside of Woodbury County, specifically Verne Marshall and Sioux City businessman Lytle. These payments, they claimed, made Havner a private, not a public, prosecutor. The first to use this argument was Des Moines bondsman Joe Gagen, who cited an affidavit from Frank Moorhead, agent with the state bureau of investigation, who said Havner "had two good friends who would take care of him," meaning Marshall and Lytle. To those

The *Cedar Rapids Gazette*'s reporting on Iowa graft and corruption was featured in the August 3, 1935 issue of *Editor & Publisher*, the national magazine covering the U.S. newspaper industry. Verne Marshall is pictured on the left, with *Gazette* managing editor John Battin on the right. *Courtesy of Douglas Lash.*

charges, Havner calmly responded, "Moorhead is mistaken about Mr. Lytle and Mr. Marshall paying or offering to pay me money"; Lytle was less even tempered, saying, "Frank Moorhead is a damned liar. If Governor Herring and his special agents want to sleep with Joe Gagen it is all right with me."[110]

At this time, however, the event getting the attention of Iowans was the ouster trial of Sioux City mayor W.D. Hayes. Some of this was due to street

violence in Sioux City among those testifying. In early August, V.W. Stephens, whose refusal to pay protection money had initially prompted Marshall to come to the northwest Iowa city in the first place, was attacked outside a café. Struck from behind with a heavy instrument, Stephens attempted to pull out a gun he'd been carrying but was knocked down to the sidewalk and beaten before he could pull out his weapon. Stephens was to be a witness in the Hayes ouster trial.[111]

Cited by the grand jury as a negligent mayor, Hayes faced Havner as a lead prosecutor with district judge W.W. Scott hearing the arguments. Speaking for nearly an hour on August 28 in a Sioux City courtroom, Havner righteously condemned the lawlessness in the northwest Iowa city that "grew and developed under the leadership of this man as mayor of Sioux City." Keeping an eye on the larger picture, Havner said his evidence would show "the set of gamblers and law violators made a hookup within the state officials so the system reached into the state capital." Hayes's defense attorney, Fred H. Free, countered that, "This petition for the mayor's removal is based on an illegal, slanderous and libelous recommendation of the grand jury."[112]

On September 5, Marshall again testified in Sioux City, this time in the Hayes case. He used the opportunity to describe in detail much of the evidence he had collected over the past year on corruption in Sioux City and its link to the state capital. He described his meeting with Duckworth in the Sioux City hotel room where the attorney finally broke down and admitted receiving protection payments. He also cited his promise to Duckworth to protect him for the time being and why he ended that promise—"because the grand jury had quit and Duckworth had not lifted a finger to keep his promise with me," adding, "It was after I heard that Duckworth was boasting that he had outfoxed me that I published his confession." Marshall also related his testimony before the legislative liquor committee and the conversation he had with Governor Herring the next day laying out all his findings. In addition, he described his correspondence with Rollinger and his visit with the bootlegger at the Fort Madison penitentiary.[113]

As the questioning proceeded, Marshall was often combative with attorneys and argued with them, especially when questioned by Free, Hayes's attorney. Judge Scott reprimanded the editor, saying, "It is important that a man occupying your position conduct himself in a dignified fashion on the stand." Marshall also freely offered his opinion of Special Prosecutor Havner, saying he, at times, acted like "the wild bull of the

The *Editor & Publisher* article on the *Gazette* featured the newspaper's July 3, 1935 front page on the indictment of Iowa attorney general Edward O'Connor and first assistant attorney general Walter Maley. *Courtesy of Douglas Lash.*

pampas" and that the two had a considerable differences of opinion on how the graft investigation was being handled.[114]

Marshall's doggedness burst through in his testimony when he was asked what his motives were in investigating corruption in Sioux City. The editor said that he was on the trail of Joe Gagen, whom he knew was the link between local protection payments and the attorney general's office, but did not find anyone who would talk until he met V.W. Stephens, printer

of baseball pool tickets in Sioux City, who told him he would be public about his payments to Gagen. On the broader level, when asked why he began his Sioux City investigations, Marshall answered the question with the directness of an aggressive, investigative journalist:

> *I feel that unless newspapers try to defend the public interest against crooks in public office, unless they try to completely hold to account men who accept public office, men who take oaths as officers of the court, and that includes every lawyer admitted to the bar, judges who accept positions on the bench, unless newspapers do their best to make all of these people, the high and the low, in elective office, respect their oaths of office and try to be decent individuals, that newspaper which tolerates that sort of thing, knowing of this and that, and doesn't do anything about it, doesn't deserve to live. Believe it or not, that is why I came to Sioux City.* [115]

As far as Hayes, however, Marshall failed to cite him for clear involvement in Sioux City's corruption ring. "I found no evidence of graft against Mayor Hayes, and I wasn't interested in any question of inefficiency, misfeasance and things of that sort." [116]

Hayes himself took the stand on September 12, telling the judge that he was too busy with city business to have time to be a "corner cop," citing the many city projects that had been completed in his three terms as mayor and the awesome challenges of a major Iowa city during the Great Depression. Judge Scott agreed. On September 17, the judge reinstated Hayes as mayor with the declaration, "I find no evidence of misconduct on the part of Mayor Hayes." [117]

At the same time, Walter Maley, first assistant attorney general, presented an amended affidavit to the Woodbury County grand jury from Lynn Geil, a freelance writer in his early twenties from Des Moines, who said he had received money from both the *Gazette* and Havner. Geil had previously testified to the grand jury that had had been at a meeting with Gagen, Maley and others where they discussed statewide protection payments. In the amended affidavit, Geil said that his prior testimony was false. Also, in his updated statement, Geil said that he had received fifteen dollars from John Battin of the *Gazette* to come to Cedar Rapids from Des Moines for a conference with Battin and Marshall. Also, meeting with Havner in Des Moines, Geil asked him how much he would get for testifying and reported that Havner replied, "Don't worry. You'll be taken care of." Geil said Havner bought him a suit of clothes, gave his

personal check for it, paid hotel bills and other expenses and gave Geil several cash advances.

In response to Geil's charges, Havner stated that he paid Geil money out from grand jury funds for witnesses and added, "If he said I made any mention of any sum deposited in the bank for him by Verne Marshall, he is mistaken." In the story covering the Geil accusation of payment, the *Gazette* editors inserted a boldfaced paragraph stating that Geil had received only fifteen dollars to come to Cedar Rapids and denied that he received any money from the newspaper for testimony. Marshall wrote, "[T]he *Gazette* was seeking information, not testimony, and it obtained plenty without relying on men of the Geil type." Marshall admitted that Geil had initially approached the *Gazette* and demanded $500 for his information but was rejected.[118]

Verne Marshall took his response directly to Governor Herring in a private letter, obviously hoping to stem any tide of accusations against him from the top of Iowa's political ladder. Hearing of threats of blackmail and character assassinations against him from parties around the state, he wrote, "I want to say that if anyone bobs up with any affidavits alleging that I have done anything irregular or at all questionable in this campaign, or attempting to smear my character, he wants to be damn sure that he has the truth and nothing but the truth in that affidavit. Unless he can prove that there is nothing but the truth in it, I will personally guarantee to make him and everyone in any way associated with his contemptible practice, seriously regret the use of perjury in any attempt at intimidation and the obstruction of public justice." He added, "You know me well enough to realize that I will stand just so much of that stuff and no more. All that I am saying now is that if mud slinging is in order, I have a truckload of mud that I can throw myself."[119]

The Geil story got much more interesting when the *Gazette* ran a story on August 27, "Witness Tells of Threats Made to Force Retraction," accusing Herring, O'Connor, Maley and Harrison of conspiring to obstruct justice by persuading Geil to change his testimony on the creation of the protection payment. The tale stemmed from still another affidavit from Geil obtained through Havner accusing Maley's office of threatening the young man. Geil claimed he had received phone calls and a visit from Harrison, telling him that Maley was considering perjury charges against Geil, strongly suggesting that he "was going to wake up one of these mornings in jail" with a $25,000 bond to pay. Geil said he was also visited at his home by Ray Maxwell, an aide to Harrison, saying directly Geil would be charged with perjury; Harrison, said Geil, was waiting in the car outside. Geil came to Harrison's

office and gave another statement but admitted to Havner that it was made under threat of prosecution and that the true statement was the one he'd given to Havner in May outlining the protection money meeting.[120]

The Sioux City hearing on throwing out the indictments began on October 7 under Judge Earl Peters of Clarinda, who had been appointed to preside over the upcoming trials. Havner was called to the stand and reported that Marshall had given him a check for $300 for expense money during the time he presented evidence to the grand jury. The lawyer said he had initially volunteered to conduct the grand jury investigation without any compensation but that "it turned out to be a bigger job than I had counted on." Marshall, too, testified in Sioux City, admitting that he had contributed between $3,000 and $4,000 to the Woodbury County grand jury, saying that "I quit spending money on July 3." Lytle also testified that he offered to pay Havner "if Woodbury County doesn't pay him" and said he granted the use of his airplane for several trips around the state for investigators and paid the railroad fare for Bert Rollinger and a guard back and forth from the Fort Madison penitentiary to testify. Lawyers for the defendants argued that Havner should not have appeared before the grand jury, disqualifying himself by accepting money from Marshall. At this point, they said, "he disqualified himself as a public prosecutor and became a private prosecutor in the employ of another private prosecutor."[121]

The latter argument failed to persuade Judge Peters. On October 16, he upheld the indictments issued by the Woodbury County grand jury and ordered the county to proceed with the trials. The defendants immediately issued a petition to the Iowa Supreme Court to overrule the Peters decision. On October 22, thirty more defendants joined Maley's appeal to the Iowa Supreme Court. Maley said that he would take the issue all the way to the U.S. Supreme Court if necessary. No one doubted him.

But it was one special indictment that held the most interest among Iowans following this legal circus—that of Attorney General Edward L. O'Connor. Spawned by the reporting of Verne Marshall, the trial of O'Connor was shaping up to become the biggest single statewide drama in Iowa.

8

THE TRIAL

The eyes of Iowans looked toward Sioux City as the trial of its elected attorney general neared in the fall of 1935.

And what some saw—particularly on the prosecution side—was the corrupting influence of Sioux City casting itself over the trial, making it nearly impossible to have a fair hearing. In mid-October, special prosecutor Havner and Woodbury County attorney Rawlings aggressively argued for a change of venue based on the local publicity generated by the graft investigations throughout the year. The attorneys were especially concerned about negative coverage directed toward the prosecution from the *Sioux City Tribune*, which, in the lawyers' words, was "particularly vicious in its attack upon the prosecution in reporting and commenting." Arguing bias on the part of the newspaper, the pair said the stockholders of the *Tribune* are "owners of all the stock in the corporation which owns the building which for years has been openly operated as a gambling house in Sioux City."[122]

Later in the month, Havner added physical threats against many of the witnesses to his reasons for a change of venue. These threats, he said, included personal violence or damages against witnesses' places of business with at least one witness refusing to sign an affidavit due to personal threats. Havner also claimed he had received threatening phone calls against his life and admitted to carrying a gun. On October 28, Havner submitted affidavits from more than four hundred people who said they did not believe the state could obtain a fair trial in Sioux City.[123]

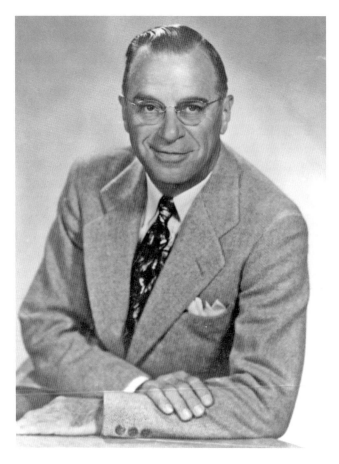

Verne Marshall confidently poses for a photo. *Courtesy of Stevie Ballard.*

Marshall reminded his readers of the risk of having the trial in Sioux City. "To undertake prosecution of these defendants against the combined forces of the state department of justice, its bureau of investigation and the vicious element that long has dominated in Woodbury County would almost hopelessly handicap Havner….Only those who know the extent of corruptive influence in western Iowa can visualize the jeopardy to the public interest. Havner's may be a losing battle to stage beyond the range of that influence, but he would be remiss in his duty if he did not put up the fight, regardless of the odds against him."[124]

Havner's efforts failed. On October 29, district judge Peters denied the change of venue request—without offering a reason—and ordered parties in the O'Connor trial to be ready by early November 1935.

Well before the trial began, Havner had laid out his "blueprint" of gambling conspiracy charges against O'Connor, as well as the others. In a forty-four-page brief made public on October 22, the attorney placed Joe Gagen of Des Moines at the center of the organization collecting "protection money" from alleged slot machine operators under the direction of Maley with the knowledge of Attorney General O'Connor. Thirteen pages alone of the document were dedicated to the anticipated testimony of Max Duckworth. The former Woodbury County attorney, according to the outline, would testify to the development of the slot machine syndicates in Sioux City and how he first accepted "protection payments." Duckworth would further describe an approval by O'Connor to move ahead with protection payments after "a fight among slot machine operators" was settled, provide testimony that Maley told Duckworth that O'Connor was aware of the "protection money" collected by Gagen and testify that he knew parties in Sioux City were paying Gagen.

Duckworth's anticipated testimony—based on his statements before the second Woodbury County grand jury—looked devastating against O'Connor. Shortly after he took office in 1933, Duckworth said he was approached by several slot machine operators—some of whom had helped elect Duckworth county attorney—who wanted to continue their setups and offered to pay him money. At first, he refused but then eventually gave in when he saw it was standard practice. At one point, conflicts between slot machine operators led to "territorial wars" between several gambling interests, with two cigar stores bombed. Duckworth declared that he would not allow any slot machine to operate as long as operators were fighting among themselves and urged all not to pay Gagen until things settled down. Duckworth said he contacted Maley, who dispatched Gagen to Sioux City to talk with the operators and sooth tempers. Later, Duckworth was told that Gagen had ended conflicts and reached agreement among warring parties.

Revelations continued in Havner's "blueprint." In a trip to Des Moines, Duckworth asked Gagen and Maley if O'Connor knew about the Sioux City payment situation and was told that the attorney general did, but Duckworth was strongly advised not to ask O'Connor about it because he didn't want to talk about it, maintaining his deniability. Duckworth, however, said he did have a conversation with O'Connor in a hotel room prior to the 1934 elections where they shared drinks. O'Connor told Duckworth that he found out that Maley had been collecting payments or at least had been permitting them. O'Connor said he confronted Maley, and the assistant denied it. O'Connor told Duckworth that he couldn't afford a scandal before

the 1934 elections, and after they were over, he was going to fire Maley. The problem, he told Duckworth, was that he knew Maley was allowing Gagen to go around the state collecting money. (O'Connor did not follow through on firing Maley, who still had his job in 1935.)

Duckworth testified that he had later heard through his Sioux City contacts that there was "some trouble" among Maley, Gagen and O'Connor and urged the locals not to pay Gagen. When the Des Moines bondsman came to Sioux City to collect, several called Duckworth and asked him what they should do. Duckworth called O'Connor and cryptically said that there was a man around town to see about something, and some of the boys wanted to know about it. According to Duckworth, O'Connor said, "Who do you mean?" Duckworth, preserving his own deniability, answered, "A man by the name of Googan." At that point, the attorney general of Iowa said, "Go ahead." Duckworth said he then called his contacts and said to proceed with the payments. Duckworth's testimony on this point seemed to tie O'Connor directly into the protection payment racket.

Havner also announced that Duckworth would testify to conferences with Iowa lieutenant governor Nelson Kraschel, liquor commissioner Harold Cooper and others where it was arranged for "protection money" collected from Sioux City liquor and slot machines businesses to be used to make up for a shortage of cash in the Sioux City liquor store. Duckworth would also testify that, after the Sioux City parties balked at paying the extra fees, E.J. Feuling, chairman of the Iowa Democratic Party, paid for part of the shortage with $1,000 in $100 bills.[125]

The voluntary testimony by Duckworth—who was given immunity by the special prosecutor—carried tremendous weight on behalf of the prosecution. Without him, the case might not have stood.

Havner wrote in the brief that he would bring forth witnesses to show that Maley told them that O'Connor owed him for help "in fixing a grand jury to keep O'Connor from being indicted for driving while intoxicated and that on account of this, O'Connor had given him [Maley] his appointment as assistant attorney general, and was to permit him to a setup so that he could make money on the side." The witness offering this perspective was Maley's mechanic, George Mineor of Des Moines, who said he had a number of conversations with Maley about his relationship with O'Connor.[126]

Havner also said publicly that he had witnesses—Clyde Mayer and his wife—who would testify that the Woodbury County slot machine payoff system was discussed between them and Joe Gagen, state agent C.W. McNaughton, assistant attorney general LeRoy Rader and Maley.[127]

On Tuesday, November 12, with Judge Earl Peters presiding, the trial began in Sioux City with Attorney General Edward O'Connor in the courtroom along with his defense team of Fred Free of Sioux City and T.E. Diamond of Sheldon. After several days of jury selection, seven men and five women were sworn in on November 14; three of the women gave their occupation as housewives, and three men were farmers.

Opening arguments began on Friday afternoon, November 15, with Havner for the prosecution and T.E. Diamond for the defense. In over two hours of oratory, Havner asserted to the jury that O'Connor "not only had knowledge of the conspiracy but also had participated in it by withholding enforcement of the law and participated in its benefits." Often shouting to the jury, the former attorney general said, "When the evidence is all in it will show the most tangled skein of the most damnable conspiracy that ever was concocted and the conspiracy will all be on the other side." For the defense, Diamond used only half an hour and calmly asserted the innocence of O'Connor, calling him "this farm boy who was raised in Johnson County in a God-fearing farm home." Lauding O'Connor's law enforcement record, he compared it favorably with Havner's record as attorney general, declaring there "never was or never will be a conspiracy with which you can tie up the attorney general." As the opposing attorneys made their cases, the courtroom, according to a *Des Moines Register* reporter, was "so quiet and solemn a pin drop could be heard at any time." During the opening arguments, O'Connor himself sat motionless at the counsel's table, cupping his chin in his hands.[128]

The first witness called on Monday morning, November 18, was the twenty-four-year-old Lynn Geil of Des Moines, who had finally decided that his testimony was about the slot machine protection setup meeting with Maley, Gagen, Sioux City beer distributor Tom Conroy and himself at the Hotel Kirkwood in Des Moines in early 1933. He quoted Maley as saying at the meeting there must be two cuts in the share of the money going to the statehouse, one for himself and "one for his chief," which meant the attorney general. Geil testified that he later met with O'Connor in a Des Moines hotel lobby at the request of his employer, Conroy, who complained "he wasn't getting his cut." The young man said he told O'Connor of the slot machine setup and that the income for protection amounted to between $5,000 and $6,000 a week. He explained he also told the attorney general that men using badges and credentials of Iowa agents were collecting the $1/week payoff, naming Gagen as one of the agents. Defense attorney Free immediately attacked the credibility of the young witness, getting

Geil to disclose under oath he had been indicted by a Polk County grand jury for breaking and entering when he was eighteen. When questioned, Geil admitted he couldn't recall the room number of the Hotel Kirkwood planning meeting. The strategy of the defense was clear. It would attack witnesses by challenging their trustworthiness and integrity, compelling the jury to reject the credibility of O'Connor's accusers.[129]

It was the next day—Tuesday, November 19, 1935—when the bombshell hit.

Max Duckworth, the prize witness for the prosecution, was called to testify late in the afternoon. Taking the stand, the disgraced Woodbury County attorney answered only a few perfunctory questions and then dramatically refused to testify, citing his Fifth Amendment rights against self-incrimination. Havner rose to his feet, absolutely flabbergasted, shouting that Duckworth had been promised immunity by the prosecution. Duckworth responded that he had been advised that neither Havner nor the grand jury had the power to grant him immunity and that he refused to answer questions on the grounds his testimony "might incriminate me and hold me up to public ignominy." Judge Peters declared that Duckworth had waived that right before the grand jury and could not claim it now, but to no avail. Duckworth simply refused to answer Havner's questions.

The Duckworth intransigence shook the prosecution's entire case and made headlines around the state. As an elected Woodbury County public official who knew the inside workings of the protection payment syndicate, the former county attorney was obviously the most credible witness among those testifying. Judge Peters cited Duckworth for contempt of court and sentenced him to the Woodbury County jail. Duckworth spent only four hours incarcerated and was released under bond, pending the Iowa Supreme Court's decision on Duckworth's petition for a review of Judge Peter's sentence.

The enraged Havner released the affidavit that Duckworth had given the prosecutors the previous July as an exhibit. The document summarized Duckworth's claim that O'Connor knew of the protection syndicate and, at best, did nothing to stop it. However, the affidavit could not be presented to the jury as evidence.[130]

At the core of Duckworth's reasoning was the same logic behind the appeal of the dozens of other individuals indicted, winding its way to the Iowa Supreme Court. Their argument was that Havner had accepted money from Verne Marshall and others, invalidating the indictments of the second Woodbury County grand jury. If the whole process was in question,

contended Duckworth, so was the promise of immunity offered by Havner and the grand jury. But without Duckworth's testimony, the prosecution's case was falling apart.

The trial was recessed so the lawyers—Havner for the state and attorney George Gorder for Duckworth—could race to Des Moines to argue the Duckworth case before five members of the Iowa Supreme Court on November 21. The issue was over whether Duckworth could legally refuse to testify under the Fifth Amendment in the trial despite having testified before the grand jury with a promise of immunity. Before the state supreme court, Duckworth's lawyer Gorder charged his client had testified before the Sioux City grand jury only because of prosecution threats, arguing that Havner told Duckworth, "Unless you come before the grand jury and tell all you know about this case I believe they might indict you." He added, "That threat is just the same as if a gun had been held at his back all the time he was in the grand jury room, and there can be no waiver of immunity unless the testimony was voluntary and free from compulsion." Havner charged back that he was only stating his opinion to Duckworth and that the former county attorney's testimony was entirely voluntary. "I have no apologies to make to this court or to any other court for that statement. I had a perfect right as prosecutor to tell him my opinion." An additional accusation made by Duckworth through his attorney was that money had been paid for perjured testimony before the grand jury, invalidating the entire process and the promise of immunity.[131]

From the pages of the *Gazette* in Cedar Rapids, Marshall angrily wrote, "The inferences and allegations as to purchase of testimony are aimed at me." Admitting that thousands of dollars had been spent by the *Gazette* to uncover corruption in Iowa, he continued, "None of that money went to buy testimony, perjured or factual, and anyone who thinks he can prove otherwise had best be sure he isn't tangled up in perjury himself."[132]

At the end of the supreme court arguments, Duckworth returned to the Woodbury County jail, surrendering himself to Sheriff Tice pending the review of the contempt of court sentence for refusing to testify.

For Verne Marshall, Duckworth's decision against testifying was no reason to hide his submitted affidavit from *Gazette* readers. Reasoning that Havner's submission of the affidavit as an exhibit to the court made it a public record, Marshall published the entire document in the *Gazette*'s Sunday edition, placing it openly before the court of public opinion. For regular readers, the affidavit offered little new information but recaptured in Duckworth's words his stinging testimony against O'Connor. In the affidavit, Duckworth admitted to

receiving between $500 and $550 a month from gamblers and slot machine operators (more than the $300 he first admitted to Marshall). He recalled his conversation with O'Connor in the fall of 1934, acknowledging the attorney general knew about the protection syndicate organized by Maley and Duckworth's cryptic phone call with O'Connor, asking if it was OK for Sioux City operators to continue paying Joe Gagen protection money after troubles raged. O'Connor, according to Duckworth, "said to go ahead, that it was all fixed up." Gazette readers saw the entire testimony—and the Woodbury County jury heard none of it.[133]

Without Duckworth's testimony, it became very clear to Marshall that an O'Connor conviction was doubtful. In his "Current Comments" column published the same day as Duckworth's grand jury affidavit, Marshall wrote, "On trial in a district court that had recessed at Sioux City, Attorney General Edward O'Connor yesterday could thank the supreme court at Des Moines for a victory which in all likelihood presages his acquittal on charges of conspiring to assist slot machine racketeers in their purchase of office protection for their lawlessness." Marshall predicted that either Duckworth's argument against testifying will be upheld or the decision would be stalled until after the trial was over.[134]

In the meantime, the O'Connor trial resumed in Sioux City—without Duckworth's testimony. Jake Harkaway, a Polish immigrant who ran a lunch counter at a Sioux City beer parlor owned by slot machine operator J.E. "Red" Brennan, took the stand and testified to seeing O'Connor at Brennan's beer garden at least three times; he said the attorney general drank at the bar while illegal slot machines were being openly operated. Harkaway also testified O'Connor had entered the backroom of the parlor where multiple slot machines were stored. The defense countered that O'Connor was at a Des Moines hospital during one period described by Harkaway, giving a blood transfusion to his son, casting doubt on Harkaway's entire testimony.[135]

On November 25, Bert Rollinger, the convict serving time in Fort Madison, took the stand to charge that he had paid $750 directly to O'Connor in a Des Moines hotel lobby for protection against illegal liquor sales and slot machine operations. O'Connor's defense team on cross-examination ruthlessly attacked the credibility of the prisoner. Rollinger admitted that he'd been a bootlegger since 1921 and had been in the state penitentiary since May 1934. He also admitted that he had been in the state mental health hospital in Cherokee for addiction to narcotics and had been using a sedative under a doctor's prescription to counter it. He

confessed he was currently under indictment in Sioux City in connection with an extortion note to kidnap his brother; Rollinger contended he was currently in prison only because his accusers committed perjury. O'Connor's lawyers countered that Rollinger had discussions with Havner, as well as Marshall, about working to overturn his current conviction if he gave testimony against O'Connor. Attorney Diamond asked Rollinger if he had bragged to several other prisoners that Lytle and Marshall had "made it worth his while to testify" and if he had told another that he was "being paid" for testifying. Rollinger denied making all these statements. But by the time he left the stand, Rollinger's credibility and his testimony had been ripped to shreds.[136]

Havner called others to the stand, such as Frank Brisbois and Clyde Mayer, both slot machine operators, who testified they paid protection money to agents, but could not establish a link to O'Connor. Brisbois admitted to making multiple protection payments to Gagen. Mayer's testimony provided interesting insights into the slot machine operation itself. He explained that machines could be adjusted to cut the customers' take to practically nothing. The machines, he explained, are set at the factory to produce paybacks to the owners of about 70 percent but can be readjusted by the owners so they won't "throw a jackpot." They simply provide enough paybacks to keep customers producing coins in hopes of a jackpot they'll never get.[137]

The prosecution brought forth the "little black book" seized earlier in the year, containing names of local slot machine operators, their payments and locations, but none of the names was Edward L. O'Connor. Havner entered telephone records into evidence showing phone calls from Joe Gagen's Sioux City hotel room to Walter Maley's residence in Des Moines, but this was no direct connection to the attorney general.[138]

A closer connection to O'Connor was revealed with the December 4 testimony of W. Cornish Beck, a self-described "general utility man for the Democratic state central committee" who was later manager of a Sioux City liquor store until late 1934. Beck testified that he had been asked by several gambling operators to help reach a truce after tensions grew violent toward the end of 1933, resulting in an exchange of bombings at liquor and gambling operations. Beck said he approached Attorney General O'Connor in his Des Moines office and requested that he withdraw state agents from Sioux City and "things would be taken care of in the usual way" and "it could be handled by the persons involved in these bombings." Beck testified that O'Connor did so, and a truce was arranged—with the help of Joe Gagen—to bring peace to the city.[139]

Havner continued to call others to the stand, describing their involvement in the liquor and slot machine protection syndicate but did not succeed in establishing a firm link to the attorney general. The Duckworth testimony was key to the case, and the former prosecutor was silent, sitting in the Woodbury County jail. On Tuesday, December 10, the prosecution rested its case without that testimony, after calling fifty-four witnesses. (None of those on the attorney general's staff was called to the stand, nor was Joe Gagen, since it was assumed they would all refuse to testify, citing Fifth Amendment rights. Said Havner, "To have called Maley to the witness stand would have been nursing the viper at the breast.")[140]

O'Connor's attorneys then took the offensive, attacking the credibility and character of those testifying against the attorney general and countering their testimony. To Rollinger's story that he talked with state investigator Park Findley on his farm and made an arrangement to meet O'Connor in a Des Moines hotel, the attorneys called on the testimony of Dr. Harry Collins of Des Moines, who said Findley was in the hospital at the time, confined to bed and then only able to walk with difficulty assisted by a cane. The defense also called forth four witnesses from the LeMars area, testifying that Rollinger's "reputation for truth and veracity" was "bad." Finally, Colonel Glenn Hayes, warden of the Fort Madison penitentiary, testified that records showed eighteen letters from Rollinger to Verne Marshall from April to December 1935, as well as two letters from Rollinger to Havner in late 1935, further insinuating that Rollinger had been urged to testify against O'Connor by the pair.[141]

Four Des Moines policemen were called to the stand—one by one—to testify that Lynn Geil had a "bad reputation" in the capital city. The defense attorneys provided further evidence that O'Connor was seen at Mercy Hospital in Des Moines the first four days in November during the time that Hathaway said he was at Brennen's beer parlor in Sioux City amid the slot machines. One by one, those testifying to O'Connor's direct involvement in the protection racket were seen as lacking credibility in front of the jury.[142]

Then, the attorneys presented evidence that O'Connor was aggressively enforcing the law—or at least prompting others to do so. County attorney Morris McMann of Kossuth County in northern Iowa testified that O'Connor had called him twice in 1933 about complaints of slot machines and told him to do his duty to "clean them up." The defense attorneys presented as evidence a letter from Maley sent to all county sheriffs to prosecute those using slot machines, expecting them to "do their full duty to arrest the offenders and institute prosecution for the violation."[143]

On Wednesday morning, December 18, the defense rested its case after calling forty-six witnesses—O'Connor did not testify. To Verne Marshall, O'Connor's silence was expected. "O'Connor's decision that he isn't eager for all the facts to come out—as he said he was when indicted— is revealed by his failure to take the stand in his own defense," wrote Marshall in the *Gazette*. "If O'Connor, a social acquaintance of several of the Sioux City leaders in that conspiracy, a visitor at their places of illegal business, knew nothing of what was going on, his ineptitude and ignorance as attorney general becomes glaringly apparent." Marshall believed that "O'Connor in all likelihood will be acquitted," given the atmosphere in Sioux City.[144]

After the defense rested, prosecutor Havner called several rebuttal witnesses to the stand, including Zon Atwood, a slot machine operator from Waterloo in northeastern Iowa. Atwood claimed that the protection system began almost immediately after O'Connor took office in January 1933 and described an incident in which Gagen himself said "O'Connor wants a hundred dollars" and telegraphed "protection money" to the attorney general. He testified he and Gagen went to a telegraph office, where Gagen counted out the one hundred dollars and gave it to the telegraph operator, presumably to send to the attorney general. Said Atwood, "I was there and Gagen told me he was wiring money to O'Connor." In cross-examination, Atwood said that he did not see what Gagen was writing. Atwood also admitted to the jury that he had been sentenced to ten years for forgery in Des Moines in 1925, joining others in the trial whose past crippled their credibility.[145]

On December 20, Havner began his lengthy summation, orating for over two and a half hours—and that was only on the first day. He assaulted O'Connor for not testifying, arguing to the jury that a normal man's reaction would be to deny the charges against him—a tactic courts in later years would declare illegal. On the defense's charge that O'Connor's accusers, such as Geil and Rollinger, fell on the wrong side of the law, Havner argued he "wouldn't expect to find a Sunday school worker or a minister of the gospel engaged in a job of this kind." He cited testimony showing that slot machines had operated all around the state and reminded the jury of a number of letters O'Connor had received about slot machines around the state and had done nothing. Actions against slot machines by state authorities were only initiated after O'Connor's indictment. On Maley's letter to county sheriffs, Havner said, "If I wanted to be just as corrupt as hell itself, that is the kind of letter I would write." The attorney general of

Iowa, the chief law enforcement office of the state, said Havner, had known of illegal operations, permitting the actions to continue until indicted.[146]

Addressing the jury with soft tones in a hushed courtroom on the second day, Havner said, "This is no ordinary criminal action. This is an action to determine whether the very foundation stones of the state government of Iowa shall be broken to pieces by a man who is the highest law enforcing officer in the state and those who have associated themselves with him. As far as a citizen of Iowa is concerned, there has not devolved upon any jury a greater responsibility than a correct determination for this case."[147]

Following Havner, defense attorney Diamond faced the jury and pointed to the able law enforcement efforts led by O'Connor on other, more serious crimes, downplaying the very action of prosecuting slot machine operators. Said Diamond, "It is vastly more important to chase criminals who are running from county to county than to chase slot machines. Yet Havner would have the attorney general spending all his time chasing slot machines over ninety-nine counties. Why, he would have been the laughing stock of the state. I am proud of Iowa's record for law enforcement over the past three years." In his summation, Diamond repeated the assault on the credibility of the witnesses—one after another—who had testified against O'Connor, challenging their truthfulness, motives and lifestyle. Diamond described Gagen as an individual who "went around telling slot machine operators he was lined up properly and, despite the activity of state agents, the poor fools fell for it. The attorney general cannot be blamed for that."[148]

Continuing the summation after the Christmas break, O'Connor's other defense attorney, Fred Free, directly attacked Rollinger's testimony on giving O'Connor money, calling the prisoner a "perjurer, extortionist, dope addict and a liar." He added, "Rollinger hatched that story about giving O'Connor $750 protection money while idling his time away in prison. The fact is he supported Verne Marshall's charges and decided they could do each other some good."[149]

The defense attorneys did not have to challenge the testimony of Max Duckworth, who was still sitting in the Woodbury County jail, waiting the verdict of the Iowa Supreme Court.

As the jury was hearing the final arguments, the man who had started it all—Verne Marshall—was resigned to O'Connor's acquittal, but he offered a look at the larger picture in the *Gazette*. "The O'Connor trial, so far as the taking of testimony is concerned, is over. An acquittal probably will result. Defense tactics worked…After all, what happens to O'Connor, Duckworth or anyone else involved in the state's betrayal by grafters and corruptionists isn't of paramount importance. The guilty should be punished and all

may escape, but if this fight has aroused the people against rascals and incompetents in places of public authority, it has served its purpose."[150]

At 11:25 a.m. on Friday, December 27, the final judgment was turned over to the twelve Woodbury County jurors who began deliberating after nearly seven weeks of listening to evidence and argument. Judge Peters gave the jury a choice of only two possible verdicts—guilty or not guilty.

The jury arrived at neither.

Debating until December 30, the jury reported to Judge Peters that it was "hopelessly deadlocked" after fifty-one hours of deliberation and four ballots with an immoveable 10–2 vote for acquittal. Two female jurors—Mrs. W.J. Wilcox and Mrs. Lydia Beach, both self-described as "housewives"—held out for the conviction of the Iowa attorney general. Beach later said that no one in the jury room offered her any arguments that could change her mind; she believed O'Connor was guilty and would not budge. With this jury announcement, Judge Peters dismissed the jury, declaring a mistrial.[151]

Calling the result an exoneration, O'Connor demanded a speedy retrial "in order to receive a complete vindication to which I am justly entitled." Havner had no comment. County attorney Rawlings immediately went into conference with the Woodbury County board of supervisors to determine the future fate of O'Connor and those of the other graft defendants. The looming burden hanging over the county was the actual cost of justice; by January 3, the cost to Woodbury County of the grand jury investigations and graft trials was $37,463 (The O'Connor trial alone cost $12,000), and there were more bills to come. In Depression-era Iowa, this was significant money. The board of supervisors was at a dire crossroads.[152]

Verne Marshall in Cedar Rapids was astonished and delighted at the result, but realistic. Issuing a statement on behalf of the *Gazette*, Marshall wrote, "Failure of the jury to agree on a verdict in the O'Connor trail is a pleasant surprise to me." Citing the lack of Duckworth's testimony, he said, "It is regrettable that the prosecution was deprived of its most valuable witness. And it is fortunate that some of the jurors sensed and understood what was happening." Writing on the day of the jury's dismissal in the *Gazette*, he urged that O'Connor resign because "the law enforcement machinery, as directed from Des Moines, has been hopelessly discredited." He continued, "In all probably, he will not be tried again. Woodbury county cannot be asked to stand the expense of another such travesty as the seven-weeks trial which ended in the jury's failure to reach a verdict. And if there is no second trial, the cloud over O'Connor immediately becomes a cloud over Iowa."[153]

With the end of the trial, Max Duckworth was released from jail on orders from the Iowa Supreme Court. The order issued from Des Moines proclaimed that Duckworth was being freed because "there is no proceeding pending now in which he could testify." On the same day, the Woodbury County board of supervisors dismissed Havner as special prosecutor, turning the responsibilities over to county attorney Rawlings.[154]

As Iowans looked to 1936, they faced still more legal wrangling and battles over corruption and graft, though many were tired of hearing about it and some—particularly in Woodbury County—were tired of paying for it. But, as the new year began, a few on the national scene were paying increased attention to the events in Iowa—especially the news coverage generated by the *Cedar Rapids Gazette*—and coming to their own conclusions about recognizing it.

9
THE PRIZE

On the last day of the tumultuous year of 1935, Verne Marshall's fingers flew over his typewriter, solemnly summarizing for the *Gazette* readers the events of the year in his "Current Comments" column. He viewed the dismissal of Havner by the Woodbury County board of supervisors as a sign the state would not see further prosecutions of other graft indictments—at least from Woodbury County. Citing the Duckworth episode, he wrote, "It is hard to believe that a county attorney in this state could accept bribes for the protection of criminals, confess that he had done so, resign from office, go to jail rather than expose the whole rotten arrangement in which he was one of the principals, and then be turned loose without punishment. Yet this is what Max Duckworth did and got away with, to the discredit and disgrace of the entire state."[155]

Also recalling his exposure of kickbacks to Democratic politicians with only the light fine and resignation of E.J. Feuling to show for it, Marshall still argued that his reporting and exposés accomplished much.

> When it set out to expose the "campaign fund contribution" graft supervised by E.J. Feuling as chieftain for the party he served so badly, and the officially protected slot machine syndicate, the Gazette did not expect to send any deeply entrenched crooks to prison. It determined to prove that these vicious evils were being inflicted on the unsuspecting people of Iowa. It believes that proof has been offered.
>
> No one longer denies that thousands of slot machines were operating in this state, and that law enforcement agents and officials were being

bribed to protect most of these machines. No one longer denied that "campaign contributions," solicited and collected by Feuling and certain associates, never reached any campaign fund, or that there was unalloyed graft in that situation.

Numerous official heads have fallen as the result of this drive for political decency and official integrity but all the guilty have managed to escape other punishment. Several have hung to their jobs. Feuling pled guilty to violation of the law that requires the reporting of campaign fund receipts and expenditures, but got off with a nominal fine. State and federal agents were fired or suspended, as the facts came out.[156]

As Marshall cast back upon the past year, he viewed this all as a vindication. But justice was uneven in Woodbury County. On January 7, 1936, district judge A.O. Wakefield directed that disbarment proceedings be drafted against Max Duckworth. The motion was based on the Sioux City Bar Association's conclusion that Duckworth had been guilty of "unfaithful and fraudulent conduct" by accepting bribes for law violation protection. Proceedings were filed with the Iowa Supreme Court, listing specific charges. On January 14, Duckworth surrendered his right to practice law to the Iowa Supreme Court, barring him from practicing law in any court in the state and rendering the disbarment proceeding unnecessary. He was thirty-two years old.[157]

Marshall contended that Duckworth's voluntary relinquishing of his license directly aided those indicted. "To have fought disbarment, Duckworth would have been compelled to take the witness stand and tell his story," the editor wrote on January 15, 1936, in the *Gazette*. "And so, again, O'Connor and many others are saved from the probable consequences of what Duckworth could tell in court if he chose to do so rather than carry the major responsibilities for all the graft and corruption of which he was but one of many beneficiaries."[158]

Days later, on January 21, the Iowa Supreme Court upheld Duckworth's contention that he could not be forced to testify at a future O'Connor trial. In a unanimous ruling, the court affirmed that an individual does not waive his Fifth Amendment rights in trial even when he testifies willingly before a grand jury. "The rule that a witness cannot be forced to give incriminating testimony is absolute and unqualified."[159]

The next day, Edward O'Connor was acquitted by a Woodbury county jury in a swift, planned motion. It began with the quick selection of a second jury, taking only two or three minutes. Once this was done, county attorney Rawlings motioned to dismiss the charges, citing the supreme court decision on the Duckworth testimony and the cost of another trial. Judge Rice,

presiding over the proceedings, admitted "a rehearing of said case would be an unwarranted, useless and additional expense to Woodbury County and would not in any manner or by any means serve the ends of justice because of the fact that a conviction is entirely improbable." With that, he directed the jury to acquit O'Connor, and it quickly agreed. In addition, he sustained Rawling's motion to dismiss perjury charges against state treasurer Wegman. Attorney Havner had previously said that it would be a darn cold day when the case was dismissed against O'Connor; on January 22, 1936, the thermometer in Sioux City read twenty-one degrees below zero.[160]

Back in Cedar Rapids, Marshall was furious. In this "Current Comments" column, he called the acquittal "the final and climactic outrage in the manipulation of the state's law enforcement machinery in behalf of that machinery's chief engineer, Attorney General Edward L. O'Connor." The reason for Marshall's anger was that the acquittal—in contrast to simply dismissing charges—meant O'Connor, due to the prohibition against double jeopardy, couldn't be prosecuted in other Iowa counties for the crimes he was charged with in Woodbury County. Marshall had in his possession an affidavit from Zon Atwood of Waterloo in Black Hawk County, testifying that Joe Gagen was the connection between the slot machine protection business and the attorney general's office.[161]

Marshall ran the story on the front page of the *Gazette*, "Reveals Payments to Gagen," the day after the directed verdict and printed the entire Atwood affidavit. But the charge was simply further information for all to see. Nothing within Iowa law could be done legally against O'Connor on the slot machine protection charge.

Conspiracy was on Marshall's mind in a letter to he wrote to FBI agent W.D. Peck, who had recently resigned from the bureau for health reasons. Commenting on the first trial, Marshall wrote, "We now know that two jurors were bought before that trial began and we have their names, but we hesitate to make any moves to reveal what we know about that jury because we have learned, to our sorrow, that it is impossible to obtain punishment for any crime on which venue exists in Woodbury county if the authorities there, the governor, and the attorney general do not want punishment to be inflicted. I used to think that I knew my way around when it came to dealing with tricky politicians, but these have given me more lessons in the last ten months than I had in the preceding 25 years."[162]

Federal authorities entered the fray when the Internal Revenue Department on February 10 asked a court order for possession of records for investigation of the income taxes of O'Connor and other defendants in the indictments

returned by the Woodbury County grand jury the previous summer. Woodbury County attorney Rawlings had refused to turn over the records, arguing that he considered them secret and privileged material of the grand jury and that he could not divulge the documents under Iowa law without authority.

By this time, however, the Bureau of Internal Revenue investigation had completely ground to a halt. According to private correspondence from Marshall to fellow journalist Walter Harrison of the *Oklahoma City Times*, the agents to whom Marshall had provided extensive information and who had compiled a mass of data on the Iowa government officials "had been called off, under political pressure." Marshall explained, "The chief of the bureau out of which they operated was transferred to a distant territory, and the agent in charge of the investigation [Peck] resigned." By late 1935, there were no signs of a federal investigation over the Iowa graft accusations. Later that year, Marshall wrote a letter to the commissioner of Internal Revenue asking about the inquiry and was told the office had all the information it needed, ending the correspondence. Nothing more emerged from the federal investigation on the Iowa probe.[163]

Efforts continued to overturn the indictments against all of those charged in Sioux City. On February 8, first assistant attorney general Maley filed a 127-page abstract with the Iowa Supreme Court, seeking to overturn all of the indictments. Among the charges were that Marshall had spent between $4,000 and $5,000 for private investigators to probe gambling operations and requested that Woodbury County retain a lawyer to permit him to examine witnesses outside the jury room; that Havner and Marshall brought Bert Rollinger, "convicted extortionist," to Sioux City and talked to him in a hotel apartment prior to his grand jury testimony; that Marshall and Sioux City businessman Lytle paid Havner extra money in addition to the approximate $10,000 paid him by the Woodbury county board of supervisors; and that the pair also paid witnesses, such as Lynn Geil, and others. Maley contended he was a victim of a political conspiracy.[164]

To Maley's charges, Marshall wrote in bold letters in the middle of an editorial on the *Gazette*'s front page: "Neither the *Gazette* nor its editor had anything to do with the selection of H.M. Havner as special prosecutor in the 'graft' cases, and neither paid him one cent for his services in that capacity. However, it would have been legal had either or both of them paid Havner any or all of his salary as special prosecutor."[165]

Maley's attorney, L.H. Salinger of Carroll, submitted a document to the Iowa Supreme Court on March 16, charging that Marshall acted as a "private investigator" for the Woodbury County grand jury. Placing Marshall

In a defeat for Marshall, the Iowa Supreme Court ruled that Harold Cooper, former head of the Iowa Liquor Commission, was not guilty of violating the law by passing state seals to Leroy Farmer of Cedar Rapids. *Courtesy of Iowa State Historical Society.*

squarely at the center of the prosecution, Salinger wrote that "Marshall is perhaps more clearly the private prosecutor for he is the master, while Havner is the servant," and said the *Gazette* editor "went before the grand jury and made speeches telling how to get proof." He specifically charged Marshall with paying Havner $700, $400 for procuring witnesses and $300 for hotel expenses. Salinger painted Marshall as an agent for the Republicans, working to bring down the attorney general and his aides in a purely partisan assault.

To these accusations, Marshall shot back in the *Gazette*: "The jurors took their jobs seriously, wanted information and got it. Neither they nor I had any thought for partisan politics."[166]

The Iowa Supreme Court struck a blow against Marshall's overall graft crusade a day later when it reversed the Linn County district court conviction of Harold M. Cooper on the charge of violating the state liquor control act, absolving him of the crime that began Marshall's investigation in late 1934. In a 7–1 decision, the court held that, while Cooper was convicted of permitting LeRoy Farmer to possess illegal liquor through the seals, the law itself passed in 1934 did not make that a crime. The law only provided for penalties to commission members for permitting fellow employees or officials to violate the act. Cooper's attorneys argued that, if the law intended to make it a crime to permit a violation of others in the state, then it should have mentioned it. Adhering to the letter of the sloppily written law, the Iowa Supreme Court accepted that argument and overturned Cooper's Linn County conviction. Linn County attorney Thompson said that Cooper "is to be congratulated upon his success in finding technical loopholes in the law, through which he escapes punishment for an act officially indefensible."[167]

One more Marshall target—the biggest one of them all—removed himself from the Iowa political scene on March 19 when Attorney General Edward O'Connor announced in Des Moines that, after two terms, he would not seek reelection for a third. He gave as a reason that he had been away from his Iowa City practice for four years and couldn't afford to remain away another two. The real reason was that the scandals had so tarnished O'Connor that he probably would not have been renominated. Already, several Iowa politicians had declared themselves candidates for the Democratic nomination for attorney general, including John Mitchell of Webster County, Democratic speaker of the Iowa House, who went on to win the post in the fall of 1936. Serving out his term, O'Connor would spend the rest of his days practicing law in Iowa City.

The fight to overturn the Woodbury County indictments continued before the Iowa Supreme Court on March 20 when Lou H. Salinger, arguing for Walter Maley, made Verne Marshall the centerpiece of his argument. He charged that Marshall acted as a "private prosecutor" before the grand jury and, using an interesting legal argument, said that the indictments were not valid because they were not signed by Marshall as required by law. Salinger accused Marshall of presenting his case against Maley and others before the grand jury, demanding that the inquiry body give him lawyers and outlining which witnesses should be called.

Havner, said Salinger, was "the paid servant of Verne Marshall, Cedar Rapids editor, who had a pecuniary interest in seeking that indictments were returned." The "pecuniary interest," he continued, lay in "rebutting possible libel suits through indictments and documents which would be filed with them." The indictments were identical to "turning a man over to his enemies through legal machinery." Salinger presented records to the court showing that Marshall had paid money to Havner; "Havner became the servant of Marshall in the teeth of statues which hold a public officer shall not accept private remuneration."

Rawlings of Woodbury County presented a weak defense before the Iowa high court. He pleaded that Marshall's appearance before the grand jury did not invalidate the charges. Rawlings, however, admitted that Havner had received $700 from Marshall, who, along with Sioux City businessman C.F. Lytle, "agreed to make it right with Havner in event that Woodbury county did not take care of his compensation." This action, argued Rawlings, was perfectly legal and within the law, but against the verbal onslaught of Salinger, the Woodbury County attorney's arguments appeared feeble. [168]

Verne Marshall, of course, was anything but. In his "Current Comment" column on the front page of the April 8 newspaper, he addressed Salinger's accusations one by one, writing that the attorney had his facts wrong. To Salinger's claim that Marshall, in testimony before the grand jury in March 1935, demanded that he be given lawyers, the editor wrote that he was nowhere near Sioux City in March. He explained that he testified before the first grand jury in April after being subpoenaed, was asked by the grand jury to remain to help the county attorney and did so. Maley's counsel is confused, he wrote, about the grand juries; it was the second one that issued the indictments, not the first one, as he claimed.

To the charge that Marshall was only defending himself against libel suits, the writer scoffed. "That is untrue. Newspapers that print the truth about corruption and graft must expect to be thus attacked, but they always can brand falsehoods as such."

As to the suffering of Maley and the others indicted, Marshall wrote "their suffering does not result from the expenditure of the *Gazette* money so much as it results from what the *Gazette* printed." He continued to make his case that his newspaper had the right to spend as much money as it wanted to run down grafters and corruptionists. Directing his ire to the weak presentation by Rawlings, Marshall wrote, "Why the new Woodbury county attorney—who got his job because the *Gazette* exposed his predecessor, Duckworth—did not open his mouth to the supreme court on that subject is unexplained."

Addressing the entire issue of the remaining indictments, Marshall said that it may be worthwhile to quash them because to continue "in Sioux City would be just one more in a long list of travesties," declaring it "would be silly, useless, a waste of public money, to assign to the Woodbury county attorney the responsibility for prosecuting a single one of those 'graft' cases." Instead, Marshall offered, those accused should put him and the *Gazette* on trial on the charge of self-promotion against libel suits. "Let those who make this allegation formally accuse the *Gazette* and its editor in a court with jurisdiction. How we would welcome just one chance to get all the facts to an untouchable jury, in an untouchable court!"[169]

Marshall took his case to a national forum days later on April 17, 1936, in Washington, D.C., when he addressed the American Society of Newspaper Editors, in a talk titled "The Value of Crusades." Using this as a chance to tout his newspaper's reporting over the past year, Marshall conceded, "I shall be amazed if one of the fifty defendants in these cases ever goes to prison, where many of them belong." As part of his accomplishments, however, he rattled off the resignations of public officials resulting from his reporting—Feuling as chairman of the Democratic party, Cooper as liquor commission chair, Duckworth as Woodbury County attorney, Kuhlmann as Sioux City public safety commissioner and others—as proof of his reporting's effect. "We put the fear of God—and of newspapers—into a lot of state officials who needed it. We have done our job, whether or not the voters, the law and the courts do theirs." Declaring that "when we find dishonesty, we raise all the hell we can," Marshall roared that "a newspaper's duty is done when it has given its readers both sides of every issue" and that it is the duty of the press to "follow the signposts of tolerance into the terrifying swamp of intolerance, if we are sure that such lunacy is what the Bill of Rights consciously was designed to offer."

Marshall concluded his address with a contradiction:

> *Denying that I am a crusader, I fly in the face of that denial by preaching at you now. I insist that to print all the news is not to crusade, but if you dissent, and your findings are against me, I ask you this: Can you visualize the place this society might carve for itself should its members miraculously agree that there are in the existing American order at least a few items and institutions in defense or condemnation of which journalism's rugged individualists might unitedly and relentlessly crusade?*[170]

The day the Pulitzer Prize Committee granted its award to the *Cedar Rapids Gazette* was the same day the Iowa Supreme Court threw out all the indictments of the Woodbury County grand jury. *Courtesy of Iowa State Historical Society.*

Marshall proudly asserted there were crusades journalists should fight. And the rest of journalism agreed—giving him and his newspaper his profession's highest honor.

On May 5, 1936, Verne Marshall and the *Cedar Rapids Gazette* were awarded the Pulitzer Prize for meritorious public service in journalism in its reporting on "corruption and misgovernment in the state of Iowa." The headline, "Gazette Pulitzer Winner," blazed across the

newspaper's front page with the subhead, "Granted Award for Campaign Against Graft."

On the very same day—and carried in a story on the same *Gazette* front page—the Iowa Supreme Court declared all the Sioux City indictments invalid, throwing them all out based on Marshall's payment of $700 to Havner. The court ruled unanimously with the exception of a single justice who did not take part, reversing Judge Earl Peter's refusal to quash the indictments. The court cited an Iowa statute that prohibited county attorneys from accepting outside funding. Wrote the justices, "When the point was reached that Havner accepted this money, from thereforth he was disqualified to act in this investigation," adding "a man cannot serve two masters."

First assistant attorney general Walter Maley, released from his indictment, couldn't resist commenting on the two events. "I noticed that the Pulitzer committee awarded the prize for the best play of the year to Robert Sherwood's 'Idiot's Delight,'" he said. "I think they got that mixed up with the *Gazette*'s activities." Maley, too, left his job at the end of 1936 with O'Connor, establishing himself as one of Des Moines's principle criminal lawyers.

Attorney Havner challenged the very heart of the decision, releasing that statement, "I never received any compensation from the *Gazette*."

Marshall admitted that day in his column to paying Havner $700, but wrote that "not one red cent has gone to Havner from the *Gazette* or myself as compensation for his services. Every dollar handed Havner was to reimburse him for the expenses of important witnesses whose testimony in most instances was invaluable to the grand jury that heard them. No one else, nor Woodbury county or the department of justice, was willing to put up the cash." Marshall charged that Woodbury County's Rawlings simply failed to make this case with this argument, adding, "Not one word of oral argument was presented to the supreme court on behalf of the people."

Evidently, the Iowa Supreme Court in 1936 saw no difference between the $700 paid for expenses and direct compensation to the special prosecutor. One of the problems was that the money contributed by Marshall solely for expenses for witnesses was registered into Havner's accounts as compensation. That evidence was a dagger used by the indicted.

The court decision did not take the sheen off the national recognition and spotlight shone on the *Gazette* and its editor. After all, Marshall wrote, "the question of the guilt or innocence of the defendants was not raised" with the court decision. "The whole effort was to put me on trial because the *Gazette* had exposed graft and corruption," he added. "That effort succeeded everywhere but in the court of public opinion. The Pulitzer award to the

Gazette for the most distinguished public service rendered in 1935 by any American newspaper, announced only last night at New York, is the answer to anyone who interprets the supreme court ruling as a vindication of the crowd indicted at Sioux City many months ago."

Standing in defiance of the court opinion with the Pulitzer Prize at his side, Verne Marshall again proudly defended all that he had done over the past year.

> *In order that there be no misunderstanding, the* Gazette *repeats once more all of the charges it has made against those who have besmirched their trusts in the public service. These charges can be proved in a fair trial. But, as has been said before, the* Gazette *has done its job. It has revealed the truth. It can not act as judge and jury, as well as witness. It has functioned as a newspaper should.*
>
> *The court of public opinion, after all, is the court whose ruling means most in these graft cases. And how unusual it is that the Pulitzer award should be announced on the eve of the supreme court decision! The* Gazette *accepts that award as a recognition of its willingness and ability to do its duty. So long as the court of public opinion upholds us, our confidence remains unshaken by what lesser courts may do.*[171]

Verne Marshall, the editor of the *Cedar Rapids Gazette* and winner of the 1936 Pulitzer Prize, had spoken.

THE AFTERMATH

On one level, the investigations and reporting launched by Verne Marshall and the *Cedar Rapids Gazette* in the mid-1930s against Iowa graft and corruption were an absolute failure.

The raid on the LeRoy Farmer illegal liquor operation in Cedar Rapids began Marshall's reporting assault on Harold Cooper, head of the newly created Iowa Liquor Control Commission. But Cooper's conviction on illegally providing state seals to Farmer to masquerade his bootleg liquor was overturned by the Iowa Supreme Court, and Cooper was acquitted of election tampering raised in another newspaper exposé by Marshall. A high-profile legislative investigation of the liquor commission uncovered little and recommended only cosmetic changes in Iowa's liquor system.

Marshall's highly publicized crusade against kickbacks from state contractors into the Democratic "campaign fund," complemented by aggressive calls in the legislature for a state investigation, fizzled almost completely. The only result was a charge of illegal campaign fund handling by Democratic Party chairman E.J. Feuling and a "slap on the wrist" with a $500 fine. A Polk County grand jury, led by a Democratic county attorney, saw no reason to initiate other charges or was persuaded by influential Iowa Democrats not to investigate further.

No one in state government or northwest Iowa went to jail or paid fines as a result of Marshall's statewide investigation into the protection syndicate shielding illegal liquor sales and slot machine operations. All those indicted by the very busy second Woodbury County grand jury in 1935—with one

exception—did not even go to trial, with the Iowa Supreme Court tossing out the indictments, pointing a wagging judicial finger at Marshall for interfering with the tools of justice. The exception, the biggest target of them all, Iowa attorney general Edward O'Connor, did go to trial, but was eventually acquitted through a court directive which prevented other state courts elsewhere in Iowa from charging him with similar crimes.

From a purely legal perspective, Marshall's forceful reporting and exposés accomplished nothing in Iowa. But Marshall was not a public prosecutor nor a lawyer. He was a reporter, a journalist who saw injustice, graft and corruption that robbed from the citizens of Iowa, and he applied his skills to exposing these wrongs to spur action. And action there was.

Harold Cooper was exposed by Marshall as a sloppy Iowa liquor commission administrator who helped a corrupt bootlegger flaunt Iowa law. Through Marshall's reporting, the state's political elite saw Cooper exposed as the incompetent manager he was and concluded he must go, forcing his resignation. This was a lesson to future administrators that such activities would not be tolerated.

Marshall's reporting on corruption within the Iowa Democratic Party forced the resignation of party chairman E.J. Feuling. Like Cooper's resignation and disgrace, this was a shot across the bow of principals in both political parties to cease these kickbacks or face the wrath of further exposés.

In assaulting the graft and corruption in Sioux City through his extensive investigative reporting, Marshall's efforts resulted in the resignations of Woodbury county attorney Max Duckworth and Sioux City public safety commissioner Henry Kuhlmann. It also resulted in an upheaval within the law enforcement network of Sioux City.

On the state level. Marshall's reporting on the liquor and slot machine protection syndicate in Iowa ended the political career of Edward O'Connor, twice elected attorney general of the state. While O'Connor didn't resign as Marshall vigorously advocated, the attorney's political career was over. O'Connor never sought political office again.

Finally, the protection network created to support illegal liquor sales and slot machine operations was exposed to the public. While it would be naïve to think that these operations completely ceased with Marshall's exposés—certainly illegal liquor-by-the-drink sales continued for decades in Iowa until legalized in 1963—the reporting by the *Cedar Rapids Gazette* editor forced state and local law enforcement officials to take their efforts seriously and crack down on violators. In 1937, O'Connor's successor, John Mitchell, led a concerted effort against slot machines, successfully requesting the Iowa

legislature strengthen enforcement powers against gambling. In his single term in office, Mitchell cleaned slot machines from the state. It's doubtful this would have happened without Marshall's watchful eye.

All these results caught the attention of the Pulitzer Prize Committee in 1936, which awarded Marshall and the *Cedar Rapids Gazette* the ultimate honor in American investigative journalism. The Pulitzer Prize was awarded to Marshall and his newspaper because they exposed these illegal actions through grit and hard work, offering the state legal system its task of taking action.

Of course, all this came at a price. The money spent by the *Gazette* and Marshall himself totaled several thousands of dollars. (Marshall was outspoken in giving credit to John L. Miller and James Faulkes, president and vice-president, respectively, of the *Gazette* company, who approved all expenses necessary to write the exposés and gave him support throughout the series.) During his four-month hunt for information, Marshall drove almost eleven thousand miles across the state and used the company's airplane for

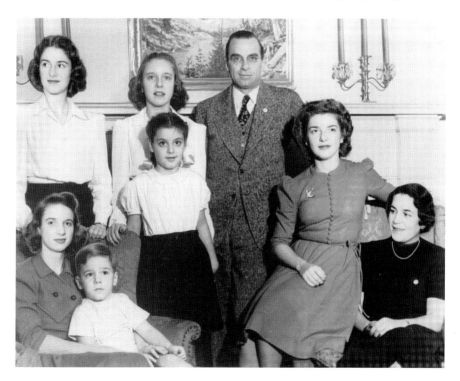

Marshall poses with his family at Christmastime, 1940. (*First row, left to right*): Jeanne, twenty-one; John Randolph, four; Marie Louise, seven; Barbara, twenty; and Clementine Marshall, Verne's second wife; (*Back row, left to right*): Patricia, eighteen; Frances, fourteen; and Verne Marshall. *Courtesy of Mollie Marti.*

emergency work that required immediate results. On a personal level, the *Gazette* and Marshall—and Marshall's family—received threats; one result is that Marshall's home and his five children at the time were provided with police protection.[172]

But none of this stopped Marshall after this tumultuous time was over, and he did not rest on his laurels. For years, he continued his aggressive reporting with a vengeance, often crossing the line between impartial journalist and public advocate. Leading up to the election of 1936, Marshall repeatedly brought up the graft and corruption that grew under the Herring administration, blaming the governor and his allies for allowing it to fester. In the 1936 election, Herring ran for the U.S. Senate seat held by incumbent Iowa Republican senator Lester Dickinson. In the race for Iowa governor, Lieutenant Governor Nelson Kraschel, a Democrat from Harlan, Iowa, ran for the top state post. Against Kraschel, Marshall blasted away at his alleged involvement in a scheme to collect money to expand slot machine protection in northwest Iowa through Duckworth and Conway. Marshall not only featured constant stories on the front page of the *Gazette* against both Democratic candidates but also took to the airwaves in paid radio programs broadcast around the state, citing the legacy of corruption and tying both Herring and Kraschel as villains in the scheme.

Marshall's editorial onslaught against the two candidates turned to naught. Both Herring and Kraschel won their respective races, continuing the success of the Iowa Democratic Party during the Great Depression of the 1930s after generations of Republican success. Both Democrats were helped by the broad success and popularity of President Franklin Roosevelt on the national ticket that year; FDR carried Iowa in 1936 as well as forty-six of the forty-eight states, resulting in a Democratic landslide throughout the nation.

The Cedar Rapids editor continued railing against Kraschel when he ran for reelection as governor two years later, continuing to link him with corruption. This time, Iowans turned out the Democratic governor and in 1938 replaced him with his Republican opponent, George Wilson of Des Moines. This may have been more of a sign of Iowans turning back to their Republican ways, as FDR's New Deal was losing its popularity.

In 1940, Marshall's career catapulted onto the national stage as the war clouds of Europe erupted with the violence of the Second World War. After Nazi Germany invaded Poland on September 1, 1939, plunging the globe into total war, most Americans believed the United States should remain neutral—with the Atlantic and Pacific Oceans seeming to protect

Verne Marshall poses prior to testimony as chairman of the No Foreign Wars Committee in 1940. *Author's collection.*

Americans from conflicts raging in both Europe and Asia. There were others who thought the United States should stand firmly with the Western Allies, especially Great Britain, which stood alone to face the Nazi onslaught after the fall of France in 1940.

Verne Marshall strongly believed in U.S. neutrality. Denying he was an isolationist, the Cedar Rapids editor instead thought the nation should build up its national defense to protect the Western Hemisphere from threats abroad. Always ready to see conspiracies behind actions, Marshall accused FDR, his allies and others of plotting to draw America into war. Essentially, Marshall viewed the conflicts between the European nations as clashes based

Marshall poses with his son, John Randolph, reviewing telegrams received after an address for the No Foreign Wars committee. *Courtesy of Mollie Marti.*

on economics rather than ideological struggles between freedom and fascism. To this end, he believed this war did not justify a single American life.

Marshall's attitudes turned to action on December 17, 1940, when he announced the creation of the No Foreign Wars Committee at the New York City's Hotel Lexington, leaving his job as the *Cedar Rapids Gazette* editor to dedicate himself full time to the effort. The organization was based in the eastern United States and directed toward public opinion and influencing the media there, despite being led by an editor from Iowa. No Foreign Wars was loosely linked with another antiwar group, the America First Committee, which was based in Chicago and led by Charles Lindbergh, a national hero who was the first to fly the Atlantic alone in 1927, and Robert E. Wood, chairman of Sears, Roebuck. Both groups were dedicated to keeping American troops out of the international conflict.

The alliance between the two organizations was short-lived. A significant reason was the personality of Verne Marshall. The very drive and aggressiveness that compelled the reporter to uncover corruption in

Iowa failed him when he tried to organize a mass movement and convince American citizens to his side.

Time after time, Marshall managed to alienate virtually everyone he encountered in this effort. Called by one journalist at the time "a man of sudden and violent enthusiasm," Marshall seemed unable to control his temper and often embarrassed himself and his supporters in public forums. One example was during a radio discussion on January 13, 1941, on the *American Town Meeting of the Air*, where the issue was "Is a Hitler Defeat Essential to the United States?" Marshall debated Dean Acheson, then a Wall Street lawyer and future secretary of state. Frequently voicing his opinions in a shrill style, Marshall sensed opposition from his audience and

Verne Marshall is shown making a speech for the No Foreign Wars Committee on NBC's *America's Town Meeting* from Cedar Rapids in 1941. *Author's collection.*

threatened members to come to the stage to fight him. He went on to accuse the moderator of planting hostile people in the audience.

Eventually, Marshall's style drove many in the antiwar effort to criticize him, drawing opposition from such different figures as former president Herbert Hoover and socialist Norman Thomas. Some accused Marshall of openly expressing anti-Semitism in his comments. Finally, the most prominent spokesman of the antiwar effort, Lindbergh, withdrew his support, saying that he found himself unable to support the No Foreign War's methods and policies. Lindbergh added he had misgivings about Marshall's "nervous condition," and "there is something about his attitude of life that disturbs me." In early 1941, Marshall charged that the Roosevelt administration knew of a German "peace plan" that it was hiding and that it was planning to seize the Federal Communications System, imposing censorship upon the wire services. [173]

William Shirer, Cedar Rapids native, CBS broadcaster and later author of the bestselling *The Rise and Fall of the Third Reich*, knew Marshall and wrote that the "strain of battling against America's entry into World War II unhinged him," explaining that "Marshall's fanaticism and his ceaseless activities proved too much for his nerves." Shirer told of an episode in 1941 when he received a call from the CBS studio in New York City where Marshall was preparing to make a speech, accusing President Roosevelt of leading the United States into war. Marshall strenuously objected to the person introducing the speech, calling him a "damn warmonger," and in the words of the caller, "he looks as if he were about to tear up the place," insisting he would only go on if introduced by Shirer. Shirer talked to Marshall over the phone, calming him down and saying that he would be introduced by a fair, impartial person, explained Shirer, better than himself. Marshall went onto make the speech. The next day, Shirer and Marshall met for lunch. Wrote Shirer, "It was a painful experience to one who had known him in his prime in our town. He was on the verge of a breakdown. It soon came and it finished him."[174]

The Cedar Rapids editor was simply no person to lead a mass movement. Marshall acknowledged the failure of the No Foreign Wars Committee to affect public attitudes, and only four months after it was formed, the committee was dissolved. The closure of the No Foreign Wars Committee also coincided with a severe nervous breakdown. The seemingly tireless editor had at last faced physical exhaustion and could no longer go on. His condition forced him into retirement. Of course, with the Japanese attack on Pearl Harbor in December 1941, all serious efforts to keep America out of World War II collapsed, bringing the nation into the worldwide conflict.

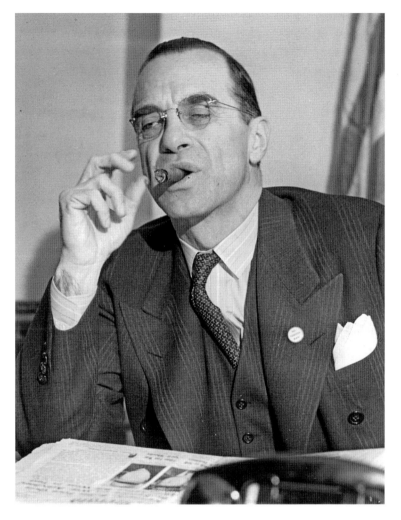

This rather unflattering photo of Verne Marshall shows him with his ever-present cigar. *Author's collection.*

Said one historian, "Marshall's fight against the Roosevelt Administration's foreign policy was conducted in the same spirit as his battle against the Sioux City slot machine gang. The Cedar Rapids editor did not lack courage; he simply failed to make the distinction between bravery and audacity so essential to mass leadership."[175]

Marshall's retirement lasted for almost a decade, and he faded from public life, both as a journalist and advocate. He reemerged in 1953 when he agreed to write weekly columns for the *Marion Sentinel* in Cedar Rapids's

neighboring town, allowing him to comment on public issues of the day. Continuing this column until 1957, Marshall opposed much of the U.S.'s Cold War foreign involvement, though he was an avid anticommunist, and severely criticized any growth of federal government power, placing himself firmly on the American right.

Verne Marshall died on March 26, 1965, at the age of seventy-five.

As the verbal and published assaults between Marshall and his foes in 1935 and 1936 fade further and further into the past, it's difficult—on one level—to see what all the fuss was about. Many of the illegal actions cited by Marshall are now legal in Iowa. Liquor by the drink has long been lawful, the state liquor monopoly stores are gone and bottled liquor can be readily purchased through private hands at Iowa liquor, grocery and convenience stores. Gambling casinos populate Iowa within easy driving distance of residents where they can legally gamble through slot machines, card games and other gaming activities. Lottery tickets are sold everywhere in Iowa. All these activities are not only all legal but are also promoted because they raise revenue for the state.

But it wasn't these core activities that Marshall attacked. What raised his ire was that public officials created a syndicate to protect law violators. Iowa citizens of that era—through their elected officials—had declared slot machines and certain liquor sales illegal. That was established. Citizens had a right to expect officials at least attempt to enforce the law. Marshall uncovered a network of public officials who profited by looking the other way, collecting money to let crimes go unabated. Add to that the clear violation of law by charging state contractors for "campaign fund" markups to do business with Iowa, and you see a level of graft as old as government itself.

The question of individual guilt and involvement is difficult to determine after so much time has passed and records faded. But the damning evidence uncovered by Marshall and the burning words of vitriol thrown back and forth between the editor and those he accused were simply too hot to believe all were innocent. There clearly was a network of corruption in Iowa in 1935. Verne Marshall investigated it like no other at the time, and he significantly contributed to its demise.

This was a moment when a steely eyed sentinel of journalism—as flawed as Marshall was—plunged fearlessly into a virtually hidden world of corruption to expose it to public scrutiny. Only by shining such a spotlight on these deeds can citizens judge whether or not their

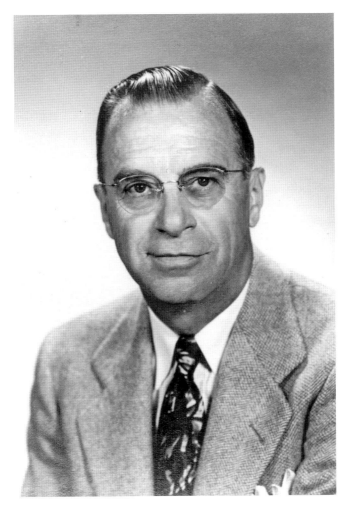

Verne Marshall. *Courtesy of the Herbert Hoover Presidential Library.*

government works for them. It is a story that stands as a testament to what a journalist should do and what a journalist must do to maintain the trust, success and endurance of American democracy. This is what Verne Marshall did.

NOTES

PROLOGUE

1. *Des Moines Register* (hereafter *DMR*), May 27, 1935; December 7, 1935; *Cedar Rapids Gazette* (hereafter *CRG*), October 23, 1935; November 27, 1935.

CHAPTER 1

2. *DMR*, May 10, 1936.
3. Ibid.
4. Ibid.
5. Verne Marshall Papers, Herbert Hoover Presidential Library, West Branch, Iowa (hereafter VMP), Box 3, "Pulitzer Prize, 1936—Letters, Articles," "Letter to Walter Harrison, *Oklahoma City Times*, January 11, 1936."
6. Persons, *University of Iowa in the Twentieth Century*, 100–1.
7. Doenecke, "Verne Marshall's Leadership of the No Foreign War Committee, 1940," 1,155.
8. *CRG*, January 14, 1931.

CHAPTER 2

9. Ibid., December 12, 1934.

10. Ibid.

11. Ibid.

12. Ibid.; *CRG*, December 13, 1934.

13. *DMR*, December 13, 1934.

14. *CRG*, December 13, 1934; December 14, 1934; *DMR*, December 14, 1934.

15. *DMR*, January 11, 1935.

16. VMP, Box 5, "Herring, Clyde," "Letter from Verne Marshall to Clyde Herring," December 31, 1934.

17. *DMR*, February 16, 1935.

18. Ibid., February 13 and 15, 1935.

19. *CRG*, February 4, 1935.

20. Ibid., March 1, 1935; VMP, Box 6, "Liquor Control Commission, State of Iowa," "Letter from Marshall to M. X. Geske, Chairman, Legislative Committee, Investigating Iowa Liquor, March 8, 1935."

21. *CRG*, March 15, 1935.

22. Ibid., March 19, 1935.

23. Ibid., March 24, 1935; DMR, February 5, 1935.

CHAPTER 3

24. *DMR*, February 3, 1935.

25. Ibid.

26. Ibid., March 1, 1935.

27. VMP, Box 6, "Investigators—Evidence Gathered by F.M.E. & W.H.L.," "W.H.L. Reports on March 3 and March 29, 1935."

28. *CRG*, April 2, 1935; *DMR*, April 2, 1935.

29. *DMR*, April 2, 1935; *CRG*, April 3, 1935.

30. Ibid., April 2, 1935.

31. Ibid., May 27, 1935; December 7, 1935; *CRG*, October 23, 1935, November 27, 1935.

32. *Iowa City Press Citizen*, June 22, 1973.

33. *CRG*, July 4, 1935; October 22, 1935.

34. Ibid., April 4, 1935.

35. Ibid., April 8, 1935.

36. VMP, Box 6, "Legal Documents," "Statement by Robert C. Toms, Cedar Rapids, April 27, 1935"; *CRG*, May 13, 1935; *Sioux City Journal*, September 6, 1935.
37. *CRG*, April 9, 1935.
38. Ibid., April 10, 1935.
39. *Sioux City Journal*, September 6, 1935.
40. "Iowa Daily's Drive on Liquor on Liquor Graft Stirs Entire State—50 Indicted," *Editor & Publisher* 68 (August 3, 1935): 1–2; *Chicago Tribune*, November 25, 1935.
41. *DMR*, April 17, 1935; *CRG*, April 17, 1935.
42. VMP, Box 6, "Legal Documents," "Sworn Statement by Wandra J. Montz, April 20, 1935."
43. *CRG*, April 23, 1935; May 1, 1935; June 23, 1935.

Chapter 4

44. Ibid., April 20, 1935.
45. Ibid.
46. VMP, Box 5, "Federal Bureau of Investigation Correspondence," Letter to Clyde Tolson, Asst. to Chief of Bureau of Investigation, April 20, 1935."
47. *CRG*, April 21, 1935.
48. Ibid., April 22, 1935.
49. Ibid., April 23, 1935.
50. Ibid., April 24, 1935.
51. Ibid., April 25, 1935.
52. Ibid., April 26, 1935.
53. Ibid., April 27, 1935.
54. Ibid., April 29, 1935.
55. Ibid., May 1, 1935.
56. *DMR*, May 1, 1935.
57. *CRG*, May 3, 1935.
58. VMP, Box 5, "General Correspondence About Trail/Information," "Transcript of Statement Given by Verne Marshall of Cedar Rapids, Iowa, May 4, 1935, at the Elms Hotel, Excelsior Springs, Missouri. Given in Presence of Willard Peck, Special Agent; Ernie Carroll Special Agent, Kansas City Division, Intelligence Unit, Internal Revenue Service."

59. VMP, Box 6, "Liquor Control Commission, State of Iowa," "Letter to Guy T. Helvering, Commissioner, Bureau of Internal Revenue from Verne Marshall, April 25, 1935.
60. *DMR*, May 9, 1935.

CHAPTER 5

61. Ibid., May 5, 1935.
62. Ibid.
63. *CRG*, May 9, 1935; May 13, 1935.
64. Ibid., May 11, 1935.
65. Ibid., May 13, 1935
66. Ibid., May 14, 1935.
67. Harlan, *Narrative History of the People of Iowa* 4:159–61; *Chicago Tribune*, November 25, 1935.
68. VMP, Box 5, "Battin, John, 1935," "Western Union Telegram from John Battin to Verne Marshall, May 15, 1935."
69. *DMR*, May 16, 1935.
70. *CRG*, May 18, 1935.
71. Ibid., May 21, 1935.
72. Ibid., May 23, 1935.
73. *DMR*, May 21, 1935.
74. Ibid.
75. *CRG*, May 21, 1935.
76. *DMR*, May 22, 1935.
77. *CRG*, May 22, 1935.
78. Ibid.
79. *DMR*, October 9, 1948.
80. *CRG*, May 27, 1935.

CHAPTER 6

81. Ibid., June 5, 1935.
82. *DMR*, May 31, 1935.
83. *CRG*, June 1, 1935.
84. Ibid., June 2, 1935.
85. Ibid., June 12, 1935.

86. VMP, Box 6, "Investigators-Evidence Gathered by F.M.E. and W.H.L.," "Letter to A.G. Goranson from Verne Marshall, June 14, 1935."

87. VMP, Box 6, "Investigators-Evidence gathered by F.M.E and W.H.L.," "F.M.E. Reports, June 16, June 19, June 20 and June 26, 1935."

88. *CRG*, June 17, 1935.

89. Ibid., June 28, 1935.

90. Ibid.

91. Ibid., July 1, 1935.

92. Ibid., July 2, 1935.

93. Ibid., July 3, 1935.

94. Ibid., July 4, 1935.

95. VMP, Box 6, "Legal Documents," "Statement of Clyde E. Mayer, July 8, 1935"; Ibid., "Investigators—H.M. Havner," "Letter from H.M. Havner to Verne Marshall, October 12, 1937."

96. *CRG*, July 14, 1935.

97. VMP, Box 6, "Investigators-Correspondence," "Letter from Marshall to C.F. Lytle, July 16, 1935."

98. Ibid., "Letter from Marshall to C.F. Lytle, July 23, 1935."

CHAPTER 7

99. *CRG*, July 22, 1935.

100. Ibid., August 5, 1935.

101. Ibid., August 7, 1935.

102. Ibid.

103. Ibid.

104. Ibid., August 15, 1935.

105. Ibid., August 12, 1935; August 19, 1935.

106. Ibid., August 18, 1935.

107. Ibid., August 22, 1935.

108. Ibid., July 30, 1935.

109. *Editor & Publisher* 68 (August 3, 1935).

110. *CRG*, August 15, 1935.

111. Ibid., August 7, 1935.

112. *DMR*, August 29, 1935.

113. Ibid., September 6, 1935; *Sioux City Journal*, September 6, 1935.

114. *CRG*, September 5, 1935.

115. *Sioux City Journal*, September 6, 1935.

116. *DMR*, September 6, 1935

117. Ibid., September 13, 1935.

118. *CRG*, August 16, 1935; *DMR*, August 19, 1935.

119. VMP, Box 5, "Herring, Clyde," "Letter from Verne Marshall to Clyde Herring, August 24, 1935."

120. *CRG*, August 27, 1935.

121. Ibid., October 7, 1935; *DMR*, October 8, 1935.

CHAPTER 8

122. *CRG*, October 14, 1935.

123. Ibid., October 25, 1935; October 28, 1935; November 4, 1935; *DMR*, October 27, 1935.

124. *CRG*, November 4, 1935.

125. Ibid., October 23, 1935.

126. VMP, Box 6, "Legal Documents," "Notice of Additional Testimony in the District Court of Iowa in and for Woodbury County—The State of Iowa, Plantiff vs. Edward L. O'Connor, et al., Defendents. Filed by M.E. Rawlings, County Attorney for Woodbury County, Iowa; and H.M. Havner, Special Prosecutor of Woodbury County, Iowa. October 23, 1935."

127. *CRG*, October 22, 1935.

128. Ibid., November 16, 1935; *DMR*, November 16, 1935.

129. *CRG*, November 18, 1935.

130. Ibid., November 19, 1935; *DMR*, November 16, 1935.

131. *CRG*, November 21, 1935.

132. Ibid.

133. Ibid., November 20, 1935.

134. Ibid.

135. *DMR*, November 23, 1935; *Sioux City Journal*, November 23, 1935.

136. *CRG*, November 25, 1935; *DMR*, November 26, 1935.

137. *DMR*, November 26, 1935; *CRG*, November 30, 1935.

138. *CRG*, November 27, 1935; December 6, 1935.

139. *CRG*, December 5, 1935; *DMR*, December 5, 1935.

140. *CRG*, December 10, 1935; December 23, 1935.

141. Ibid., December 11, 1935; December 12, 1935; December 13, 1935; December 18, 1935.

142. Ibid., December 13, 1935.

143. Ibid., December 17, 1935.

144. Ibid., December 18, 1935.
145. Ibid., December 19, 1935; *DMR*, December 19, 1935.
146. *CRG*, December 21, 1935.
147. *DMR*, December 21, 1935.
148. Ibid., December 24, 1935; *CRG*, December 26, 1935
149. *DMR*, December 27, 1935.
150. *CRG*, December 21, 1935.
151. Ibid., December 30, 1935.
152. Ibid., DMR, December 30, 1935
153. *CRG*, December 30, 1935; VMP, Box 7, "Things of Interest," Western Union Telegram, Statement of *Cedar Rapids Gazette*, December 28, 1935; *CRG*, December 30, 1935.
154. *CRG*, December 31, 1935.

Chapter 9

155. Ibid.
156. Ibid.
157. Ibid., January 14, 1936; January 15, 1936
158. Ibid., January 15, 1936.
159. Ibid., January 21, 1936.
160. Ibid., January 22, 1936; *DMR*, January 23, 1936.
161. *CRG*, January 22, 1936; VMP, Box 6, "Investigators-Correspondence," "State of Iowa-County of Black Hawk, Affidavit by Zon Atwood, December 31, 1935."
162. VMP, Box 5, "General Correspondence," "Letter to W.D. Peck, FBI Agent, Los Angeles, CA, January 29, 1936.
163. Ibid., Box 3, "Pulitzer Prize, 1936—Letter, Articles," "Letter to Walter Harrison, Oklahoma City Times, January 11, 1936"; *DMR*, February 11, 1936.
164. *CRG*, February 8, 1936.
165. Ibid.
166. Ibid., March 16, 1936.
167. Ibid., March 17, 1936; March 19, 1936.
168. Ibid., March 20, 1936.
169. Ibid., April 8, 1936.
170. Ibid., April 17, 1936.
171. Ibid., May 5, 1936.

EPILOGUE

172. VMP, Box 3, "Pulitzer Prize, 1936—Letter, Articles," "Letter to Walter Harrison, *Oklahoma City Times,* January 11, 1936"; *CRG,* June, 5, 1936.

173. Doenecke, "Verne Marshall's Leadership of the No Foreign War Committee, 1940," 1,161–67.

174. Shirer, *20th Century Journey,* 179–80.

175. Doenecke, "Verne Marshall's Leadership of the No Foreign War Committeee, 1940," 1,171.

BIBLIOGRAPHY

Cedar Rapids Gazette

Chicago Tribune

Des Moines Register

Doenecke, Justus D. "Verne Marshall's Leadership of the No Foreign War Committee, 1940," *Annals of Iowa,* Winter 1973.

Editor & Publisher

Harlan, Edgar Rubey. *A Narrative History of the People of Iowa.* New York: American Historical Society, 1931.

Iowa City Press Citizen

Mills, George. *One-Armed Bandits and Other Stories of Iowa's Past and Present.* Ames, IA: Focus Books, 1997.

Persons, Stow. *The University of Iowa in the Twentieth Century: An Institutional History.* Iowa City: University of Iowa Press, 1990.

Sage, Leland. *A History of Iowa.* Ames: Iowa State University Press, 1974.

BIBLIOGRAPHY

Shirer, William L. *20ᵗʰ Century Journey: A Memoir of a Life and the Times.* Vol. 1, *The Start, 1904–1930.* Boston: Little, Brown & Company, 1985.

Sioux City Tribune

Verne Marshall Papers. Herbert Hoover Presidential Library. West Branch, Iowa.

INDEX

ABOUT THE AUTHOR

J erry Harrington of Iowa City, Iowa, has spent a lifetime writing about Iowa history. A frequent contributor to *Iowa History Journal* (IHJ), he won the 2016 George Mills–Louise Noun Popular History Award from the Iowa State Historical Society for the IHJ series "Iowa Governors of Influence."

Harrington recently retired as marketing public relations manager for DuPont Pioneer in Johnston, Iowa. He has worked for advertising/public relations agencies in Cedar Rapids, Iowa; Milwaukee, Wisconsin; and Rochester, New York. He has also worked for newspapers in Spencer and Clear Lake, Iowa.

He graduated from Cornell College, Mount Vernon, Iowa, in 1977 with degrees in English and political science and received his master's degree in history from the University of Iowa in 1981.

Visit us at
www.historypress.net

This title is also available as an e-book